LEGENDARY LOCALS

OF

HOBOKEN

NEW JERSEY

ALAN SKONTRA

LEGENDARY
LOCALS

Legendary Locals is an imprint of Arcadia Publishing
Charleston, South Carolina

Printed in the United States of America

Library of Congress Control Number: 2013938124

For all general information, please contact Arcadia Publishing:
Telephone 843-853-2070
Fax 843-853-0044
E-mail sales@arcadiapublishing.com
For customer service and orders:
Toll-Free 1-888-313-2665

Visit us on the Internet at www.arcadiapublishing.com

Dedication
For my father, who looked across the water and wondered what he would find on the other side.

On the Front Cover: Clockwise from top left:
Marlon Brando on the set of *On the Waterfront* (Courtesy of the Hoboken Historical Museum, page 59); baker Carlo Guastaferro (Courtesy of HHM, page 71); chef Anthony Pino (Courtesy of Anthony Pino, page 74); Gen. John Pershing landing in Hoboken (Courtesy of HHM, page 21); Sir Thomas Lipton (Courtesy of HHM, page 56); Dinorah Vargas and Jaclyn Cherubini of the Hoboken Shelter (Courtesy of Jaclyn Cherubini, page 86); brand consultant Elizabeth Barry (Courtesy of Elizabeth Barry, page 111); actor Joe Pantoliano (Courtesy of Joe Pantoliano, page 47); and center: Col. John Stevens (Courtesy of Stevens Institute of Technology, page 10).

On the Back Cover: From left to right:
Frank Sinatra at St. Francis Church (Courtesy of the HHM, page 40); the board of Party With Purpose at its winter benefit (Courtesy of Party With Purpose, page 97).

LEGENDARY LOCALS

OF

HOBOKEN

NEW JERSEY

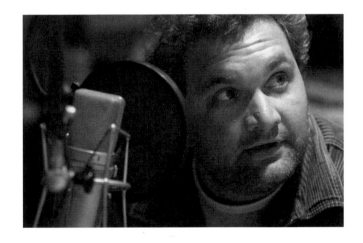

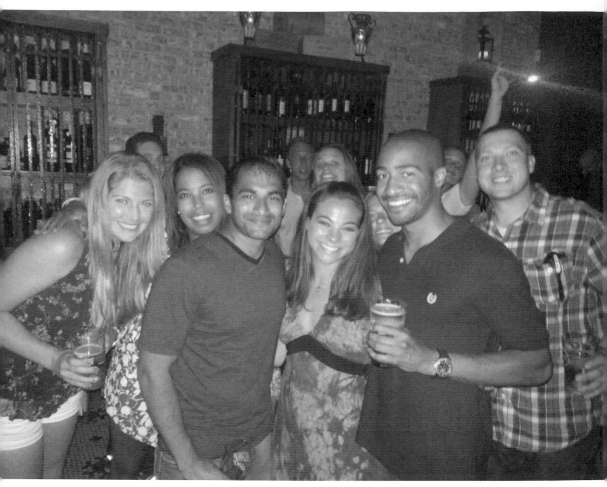

The Kids Are All Right

These smiling twentysomethings represent one of Hoboken's stock groups of residents. They are young and eager, and they are well-educated and work professional jobs in Manhattan. They stay physically fit by playing touch football, softball, and other sports in local leagues. They also attend charity events for causes such as the Hoboken Shelter and the Hoboken Relay for Life, and they spend their weekend time socializing in Hoboken's lively bar scene. (Courtesy of Jason Ricketts.)

Page 1: Our Artie

New Jersey native Artie Lange has reached great heights as a comedian, radio voice, and actor. He was an original cast member on the television show *MADtv*, costarred in the movie *Dirty Work*, and has appeared in other movies such as *Elf* and *Old School*. Lange has cowritten a best-selling biography, *Too Fat to Fish*, and was a longtime radio voice on *The Howard Stern Show* before becoming host of his own show in 2013. Lange has performed for his fellow Hoboken residents during the Hoboken Comedy Festival and during charity shows at the Elks Lodge. (Courtesy of Artie Lange.)

CONTENTS

ACKNOWLEDGMENTS

These are the first words that you will read from me in this book, but they are the last ones I wrote for it. I grew up in a blue-collar family, and I don't like to relax until I know the job is done. Even when I do relax, I think about what I could have done better.

I believe I fail as a writer because I will never be able to express how much I appreciate living in Hoboken, my home since 2009. This book is my best attempt to date. I want to thank the people of Hoboken for letting me get to know them. Thanks to everyone who reads this book, too. A writer wants people to read what he or she writes, and I consider it an honor whenever a reader does so.

I appreciate Arcadia Publishing for giving me this opportunity. I am encouraged that they thought me capable of writing a book that meets their high standards. I have found working with editor Erin Vosgien and the rest of the team to be a pleasure, and I thank them for putting this project together.

Thanks to the Hoboken Historical Museum for giving me access to its large collection of photographs. Director Robert Foster has helped me understand much of Hoboken's history. I very much appreciate the work of collections manager David Webster, who spent a lot of time processing my photograph requests. Thanks also to Leah Loscutoff, the librarian at Stevens Institute of Technology, for sending me several images.

I want to thank Derek Meyer for helping me start as a writer, and Caren Matzner and Claire Moses for giving me my first opportunities to do it professionally. Thanks to my business clients for being patient with me during this project. Thanks to my roommates Julia Bruder, Caitrin O'Sullivan, and Tiffany Watson for putting up with me living like a derelict these last few months. I'll get to those dishes now, I promise.

I especially want to thank my friends in Chesterfield, Virginia, and the Gary Lopez family for welcoming and understanding me. Finally, I want to thank my mother, Maria, and my sister, Sonia, for their many means of support.

Regards,
Alan Skontra
www.alanskontra.com
@alanskontra

INTRODUCTION

There are conflicting reports about the origin of the name Hoboken. Most think the name comes from the Dutch colonists who settled in the area during the mid-17th century. Others say the name comes from the Lenape tribes who first populated the shores of the Hudson River. In any case, the name Hoboken has spread far beyond the borders of New Jersey. Millions know it as the birthplace of baseball, the birthplace of Frank Sinatra, and the setting for the popular television show *Cake Boss*, among many other things.

The Stevens family began to build Hoboken after the Revolutionary War. Col. John Stevens purchased a pristine square mile and more that the new state of New Jersey had seized from a British loyalist, and he built an estate that people came to call the Castle Point bluff. Stevens and his sons Robert and John experimented with steam shipping and rail transit. Their successes include the first steam-powered commercial ferry and the first railroad in New Jersey. Stevens's son Edwin used the family's wealth to build what is now a prestigious engineering college, Stevens Institute of Technology.

The Stevens family started the Hoboken Land Improvement Company to draw streets and sell plots. People, including many immigrants, soon came to settle. The residents eligible to vote in 1855 voted to incorporate as a city. Hoboken had a name and a place. It would then have many identities.

For much of the 19th century, New Yorkers enjoyed crossing the Hudson and spending the day in Hoboken, in what was still a very pastoral place. New York's political elite formed a social club that met in Hoboken. The New York Yacht Club actually met in a Hoboken boathouse. In 1846, at Hoboken's Elysian Fields, two teams played what many historians consider to be the first game of baseball.

The city's population grew, peaking at 70,000 in 1910—20,000 more than would live there a century later. German immigrants came to dominate the city and would (mostly) coexist with later waves of Irish, Italians, Puerto Ricans and others. The Germans, Norwegians, and Dutch operated international shipping lines from Hoboken's waterfront to Europe. Both natives and new residents opened businesses, including many factories.

Hoboken remained an industrious though relatively quiet city until World War I. No other city in America felt the shock of that war more. The federal government commandeered Hoboken, declaring martial law within much of its border. The Army sent its entire force, some three million soldiers, from Hoboken to Europe and back during 1917 and 1918. The government's presence severely stifled Hoboken's German community. Many Germans lost their ability to move freely, and those who owned businesses usually lost them. Many left the city for good.

After the war, the city recovered with an influx of newer residents, especially from Italy, and it still remained an industrial and transportation hub. Despite a hard, blue-collar ethos, and in many cases, stark poverty, people found reasons to be happy by spending time with their families and neighbors. This was a time when every adult on a stoop helped raise every child in the neighborhood. People frequented popular cultural events such as the St. Ann's summer festival, and they developed a strong sense of community.

But there were bad times too. The city's docks were corrupt and violent enough to inspire the movie *On the Waterfront*. Mobsters seized opportunities. Despite the sense of community, the city was also full of lonely and desperate men who whittled their lives in the city's bars. Supposedly the word "hobo" comes from Hoboken.

By the 1970s, things really turned bad. The shipping left for bigger ports, the factories relocated, and the railroads moved. Hoboken was a poor and dangerous city with high unemployment. There were violent crimes and even riots.

Things would have to get even worse before they could get better. Some of the city's leaders saw an opening for a renaissance, but that meant attracting more wealth by expunging the poor. The city closed

every boardinghouse, sending hundreds of poor people onto the streets. Until the local clergy fought to open a shelter, the city's tendency was to escort the homeless to the city limits and warn them never to return. A series of what many suspect to be arson fires destroyed several low-income buildings, displaced hundreds, and killed dozens.

Real estate developers seized the opportunity. They bought old, cheap brownstones, renovated them, and turned them into modern apartments for huge profits. They knocked down old buildings and built luxury homes. Many longtime families left rather than pay escalating rents. Thousands of young, educated, and successful professionals came to replace them. Many who got married decided to stay and raise their families rather than shuffle to the suburbs.

As harsh as gentrification has been, the new residents have also saved Hoboken. Their property tax dollars support the schools for all the city's children. They support the local businesses, shops, and restaurants. They have made Hoboken safer, fought corruption, cleaned the waterfront, and created more open space.

Hoboken is hip now. Rock stars hold concerts on the piers and shoot videos uptown. Sexy celebrities sleep in the ritzy waterfront hotel. The New York press pumps Hoboken's restaurants and boutiques. On weekends it seems all the young bucks and pretty fashionistas in north Jersey cavort downtown.

Years ago Hoboken was a geographic island, and culturally it still feels like one. It lies yards away from the biggest city in America and faces millions in suburban sprawl, and yet its borders trace rivers, coves, cliffs and railroad tracks. The city just feels isolated, not quite Manhattan, not quite Jersey.

That's Hoboken's identity today: a city apart, a hotspot, and to a shuffled deck of 50,000, a home. It is a mix of proud natives who have found ways to stay, peppy young families pushing strollers along the sidewalk, transient twentysomethings spending their stewed youth, and successful, single midlifers who are having too much fun to leave. These are the people who live, work, and play now in the once-pastoral parcel of land Colonel Stevens bought so many years ago.

CHAPTER ONE

Elysian

It must be hard for modern Hobokenites to believe that their compact, dense, concrete- and brick-covered city was once green, open, and pastoral. Perhaps modern New Yorkers who scoff at anything "Jersey" would also struggle to believe that their urban ancestors relished crossing the Hudson River to seek leisure in the land that would become Hoboken. But it's all true.

After the Revolutionary War, Col. John Stevens bought the vacated Bayard's farm, built his estate there, and set about building a city. His family's Hoboken Land Improvement Company demarcated streets in the square mile vicinity, sold lots, and encouraged growth. Immigrants from Europe settled, moved into homes, and opened businesses. Many came from Germany, enough to earn Hoboken the nickname "Little Bremen."

Many of Colonel Stevens's New York friends came often to Hoboken's pastures to eat, drink, and socialize with the Turtle Club, a group that included Alexander Hamilton, Aaron Burr, and other national leaders. Other New Yorkers came to stroll along the waterfront or sip from the mineral springs in secluded Sybil's Cave. In 1846, two teams from Manhattan came to Hoboken's Elysian Fields to play what many historians consider to be the first organized and recorded game of baseball.

However, by the 1870s, the baseball teams had moved their games to newly built stadiums elsewhere, and people were finding less space for leisure. Hoboken was becoming more industrial, and soon factories and row houses covered the fields. Smokestacks polluted the fresh air. The city went from green to brick red and coal black. Hoboken had shed its pastoral roots.

By the turn of the 20th century, Hoboken was a heavily congested city with more than 70,000 residents, 20,000 more than live there in the early 21st century. Many residents worked for the several international shipping lines that operated docks on the Hudson waterfront. When the United States entered World War I in 1917, the federal government commandeered Hoboken's docks and used them to send more than three million soldiers to Europe. The federal presence had a profound effect on Hoboken by restricting civilian movement, closing certain businesses, and intimidating many of the city's Germans to move. Others would soon replace them, moving into the tenements, taking the hard jobs, and joining the machine.

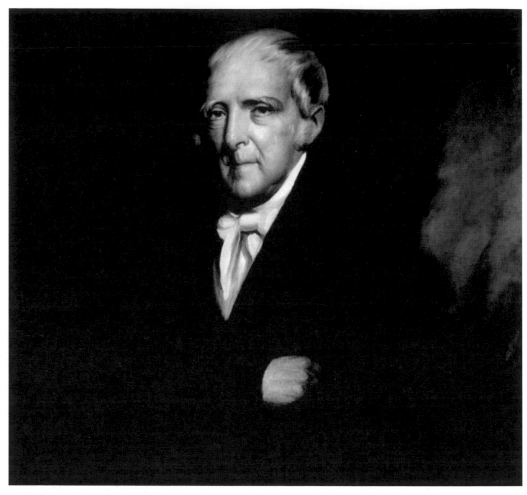

The Colonel

Not only was John Stevens the founder of Hoboken, he was one of America's founding fathers, as well as a technical innovator, businessman, and patriarch of a prestigious family. Stevens was born the son of John Stevens, a New Jersey delegate to the Continental Congress. The younger Stevens graduated from King's College, now known as Columbia University, in 1768 and became a captain and later a colonel in the Continental Army in 1776. After the Revolutionary War, Colonel Stevens bought a parcel of land on the west bank of the Hudson River that formerly belonged to a Crown loyalist. There, Stevens built an estate featuring the Georgian mansion that gave name to Castle Point bluff. He served as treasurer of New Jersey, and together with his wife, Rachel, he raised 11 children. As the Stevens estate grew, so did the settlements around it, which gradually linked to form Hoboken. As Hoboken grew, Colonel Stevens stayed busy by making major contributions to science and transportation. At the turn of the 19th century, he began experimenting with steam-powered boats. In 1809, his *Phoenix* went down the Hudson River and all the way to Philadelphia, becoming the first steamship to survive ocean waters. Colonel Stevens launched the first steam-powered ferry service in 1811, sending passengers and goods across the Hudson on the *Juliana*. Four years later, Colonel Stevens was part of the company that won the first railroad charter in the United States, and by 1832, he and his family owned the first operational railroad in New Jersey. By the time of his death in 1838, Colonel Stevens had left his mark on what became the city of Hoboken, and though he was the first person from Hoboken to make a significant impact on the rest of the United States, he would not be the last. (Courtesy of Stevens Institute of Technology.)

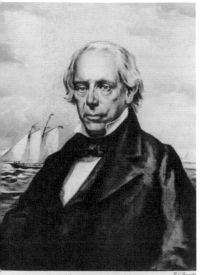

COMMODORE JOHN COX STEVENS
*6 1786 - 1857 *
Yachtsman

Courtesy of The Overydale Press

The Yachtsman

The oldest of Colonel Stevens's sons, John Cox Stevens had an ocean-going passion his entire life. In 1844, he cofounded and served as first commodore of the New York Yacht Club, which used a boathouse in Hoboken as its headquarters. John, his brother Edwin, and other members built the *America*, the racing yacht that defeated all English challengers in 1851 to win what has since become the America's Cup. (Courtesy of Stevens Institute of Technology.)

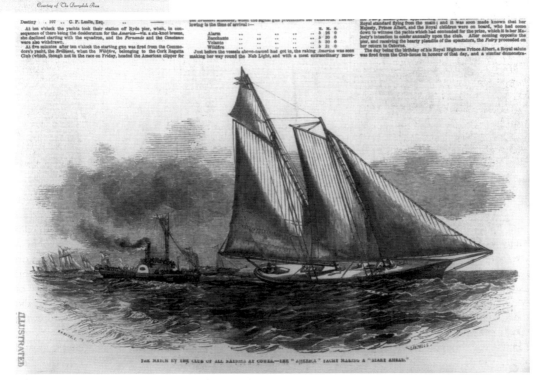

The *America*

John Cox Stevens's yacht, the *America*, spanned over 100 feet long and weighed 170 tons. Stevens was confident the yacht could compete with the best of British shipping, entering it in the Royal Yacht Squadron's annual regatta on August 22, 1851. The *America* won the 53-mile, seven-hour race around the Isle of Wight, crossing the finish line around 6 p.m. with a lead of 18 minutes. (Courtesy of Library of Congress.)

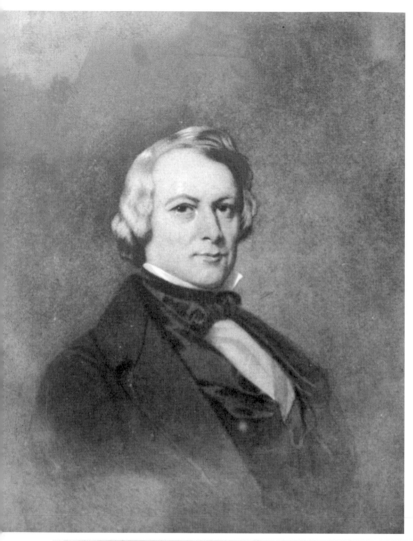

The Railroad Man
The second of Colonel Stevens's children, Robert Stevens helped his father build and send the *Phoenix* down the Hudson. Later, he designed many improvements to shipping and rail technology, including the flanged, *T*-style rail, which is still the way trains stay on tracks. Robert ran the Stevens family's railroad, the Camden & Amboy Railroad and Transportation Company, the first operational railroad in New Jersey. (Courtesy of Stevens Institute of Technology.)

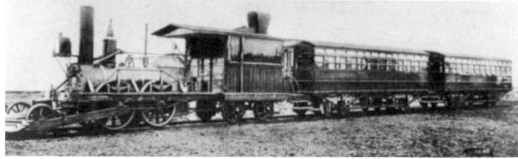

The *John Bull*
In 1831, Robert Stevens imported the *John Bull* locomotive from England. A year later, it became the first steam locomotive to run on an American railroad. The Camden & Amboy used it until 1866. The Smithsonian, which now displays the *John Bull*, successfully operated it as recently as 1981. (Courtesy of Stevens Institute of Technology.)

The Founder

When Edwin Stevens, the sixth child in the family, died in 1868, his will left money to found the Stevens Institute of Technology, which is now one of the top engineering universities in the United States. The school capped Stevens's long career as an engineer, businessman, and community leader. He designed ships for the US Navy and served as highway commissioner for the State of New Jersey. (Courtesy of Stevens Institute of Technology.)

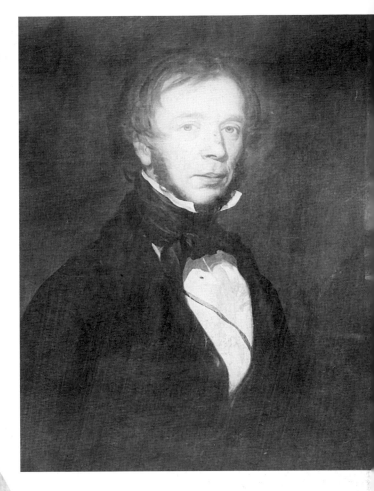

The Matriarch

When her husband, Edwin, died in 1868, Martha Bayard Stevens led the effort to fulfill his wish to build an engineering school on the family's land along the Hudson River. Stevens Institute of Technology opened in 1870 and is still training successful engineers. Martha Stevens also donated money and land to begin the Hoboken Public Library, Church Square Park, Elysian Park, and various trade schools. (Courtesy of Stevens Institute of Technology.)

SCENE ON THE GROUNDS OF THE HOBOKEN TURTLE CLU

[SEE PAGE 78.]

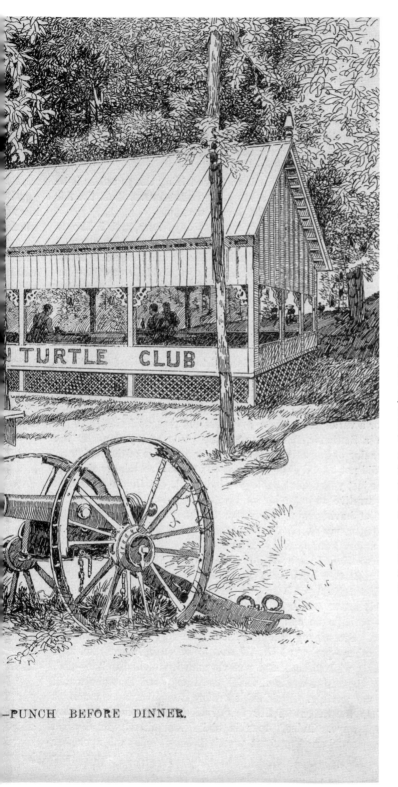

TURTLE CLUB

—PUNCH BEFORE DINNER.

The Turtle Club

"It must first be premised that this is no ordinary club, from the day of its foundation it has existed for but one thing, the principal of epicurean pleasure," Col. John Stevens said about the social club he founded in 1796, the Turtle Club. All of New York's big businessmen and politicians, including Alexander Hamilton, Aaron Burr, and John Jay, would regularly cross the Hudson to eat, drink, and banter in Hoboken. Even George Washington was an honorary member. Stevens served soup from river turtles he slaughtered to stop them from eating his chickens grazing on the shore, and the tradition stuck. By the 1870s, the group began meeting in New York, though it still called itself the Hoboken Turtle Club, and it lasted until the 1940s. (Courtesy of HHM.)

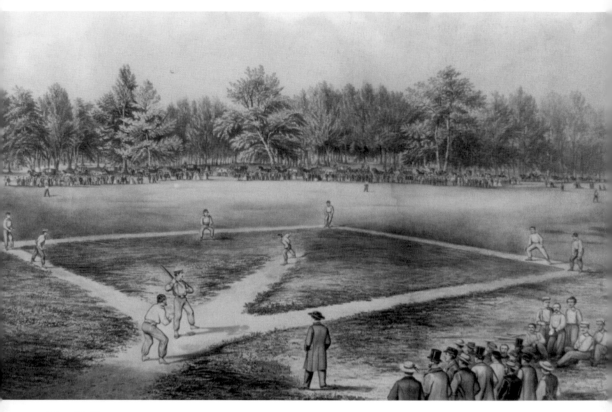

Play Ball

On June 19, 1846, two groups of nine men met on Hoboken's Elysian Fields for a contest of baseball, the new, elaborate game Alexander Cartwright had begun designing months before out of traditional stick-and-ball games. The game was a blowout, with the visiting New York Nine beating Cartwright's Knickerbockers 23-1, but America would still become hooked. Though historians are reluctant to draw an exact line in baseball's evolution from various English games into the American national pastime, many of them credit the game played in Hoboken as likely being the first one organized and recorded under modern rules. This famous Currier and Ives lithograph from 1866 depicts a championship match between the Mutual Club of Manhattan and the Atlantic Club of Brooklyn, an event that drew thousands of spectators to Hoboken. Players continued to use the Elysian Fields until the 1870s before shifting to newer, fenced stadiums with seating elsewhere. Though urbanization eventually paved over the Elysian Fields in the 20th century, Hoboken maintains a namesake park nearby, plus a monument and four sidewalk plaques, one for home plate and three bases, at the intersection of Eleventh and Washington Streets. The Hoboken Historical Museum sponsors a throwback team that plays with 19th-century rules, the Mile Square Theatre Company hosts an annual production of original plays about baseball, and various other businesses and groups in the city highlight Hoboken's role as a birthplace of baseball. (Courtesy of Library of Congress.)

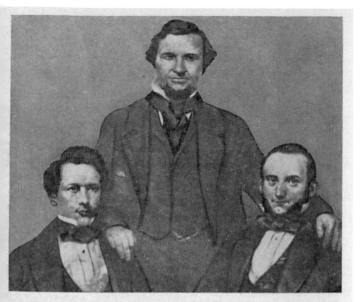

Mayor Clickener

After Hoboken's eligible residents voted to incorporate as a city in 1855, medicine seller and Democratic politician Cornelius V. Clickener, an incorporation supporter, became the city's first mayor. He won election with 55 percent of the vote but lost reelection in 1857. Clickener, center in this newspaper photograph with newly elected commissioners George Brampton, left, and James K. Brush, also served as a state senator and as bank commissioner for the State of New Jersey. (Courtesy of HHM.)

FIRST MAYOR — Cornelius V. Clickener, center, poses with Councilmen George Brampton, left, and James K. Brush after he was elected Hoboken's first mayor on April 10, 1855. Clickener, who defeated Benjamin J. Taylor by a vote of 366 to 299, later became Hudson County's state senator.

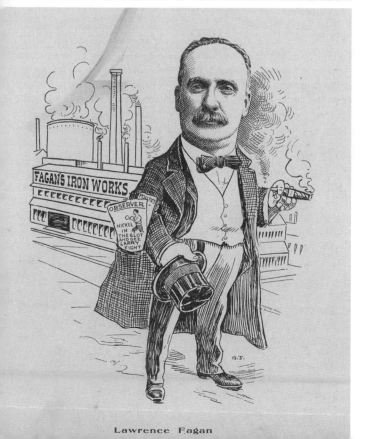

Lawrence Fagan

Mayor Fagan

In 1872, Dublin-born blacksmith Lawrence Fagan cofounded Architectural Iron Works, a company that made iron accessories for buildings out of a factory on Third and Jefferson Streets. He became wealthy and turned to politics. Fagan, a Democrat, served two terms as a state assemblyman. He proposed a forgotten plan of splitting Hudson County into two halves, with the northern half becoming a new Hamilton County. Fagan ran for mayor as a reform alternative to the local political machine known as the Ring. He won and served from 1893 to 1901. (Courtesy of HHM.)

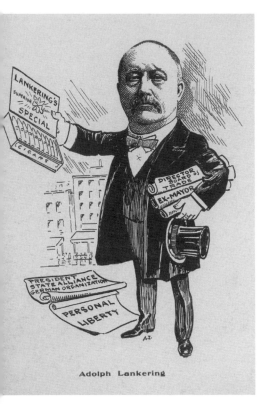

Adolph Lankering

Mayor Lankering
Adolph Lankering was Hoboken's 23rd mayor, serving from 1901 to 1906. At various times, he also served as postmaster for the city, as president of a German American organization, and as director of the Hoboken Board of Trade. Lankering ran a cigar company with his brother Frederick. Frederick managed the production end from a factory in nearby Paterson, and Adolph managed a storefront at 58 Newark Street. (Courtesy of HHM.)

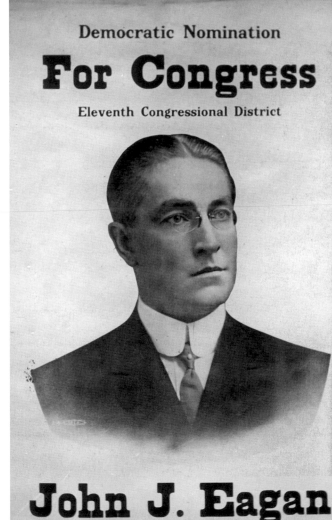

Democratic Nomination

For Congress

Eleventh Congressional District

John J. Eagan

Congressman Eagan
Business teacher John J. Eagan was born in Hoboken in 1872 and had the distinction of serving five terms from New Jersey's 11th Congressional District. He was first elected in 1912, won reelection in 1914, 1916, and 1918, lost reelection in 1920, won his seat back in 1922, and lost it for good in 1924. After leaving Congress, Eagan served as president of the Weehawken Board of Education and as collector of taxes. (Courtesy of HHM.)

Superintendent Demarest

Since he had been a successful teacher and textbook author, the Hoboken Board of Education named Abraham J. Demarest the city's first superintendent of public schools around 1905, a position he held until 1920. The building on Fourth and Garden Streets that bears his name was built in 1911 and served as a high school until 1962. It later became a middle school and now hosts grades three to five of the Elysian Charter School. (Courtesy of HHM.)

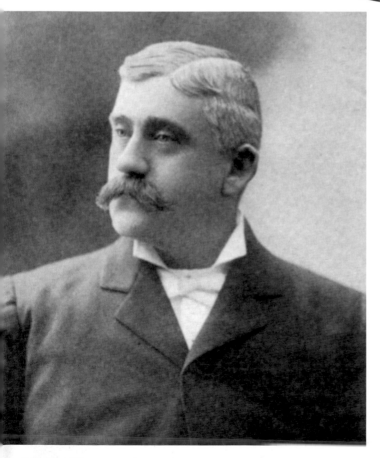

Chief Applegate

Ivins D. Applegate became Hoboken's first fire chief when the volunteer department turned professional in 1891. During Applegate's tenure, the department battled the largest fire in the city's history, one that started in a North German Lloyd shipping warehouse near Fourth Street on June 30, 1900. The fire burned for three days, killed over 300 people, destroyed two piers and over 30 ships, and caused $125 million in damages in 2014 dollars. Applegate also helped stop the famous Lackawanna Terminal fire of 1905, which destroyed the building, two ferries, and a popular restaurant. (Courtesy of HHM.)

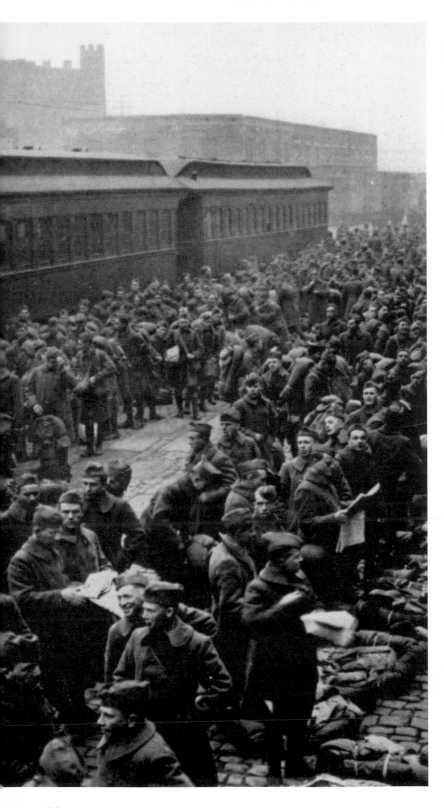

Heaven, Hell, or Hoboken

The men in this photograph were just some of the three million soldiers who fought for the American Expeditionary Force during World War I. All of them sailed to Europe from Hoboken. During 1917 and 1918, men from all over the country boarded cramped trains and rode bumpy trips, often for days, until they arrived at Hoboken, where they would board cramped boats for a long journey across the Atlantic Ocean. While sailing, they would have to dodge German submarines just to land in Europe, where they could then die at any moment from bullets, bayonets, bombs, poison gas, disease, and other horrific causes. The soldiers expressed gallows humor by popularizing the phrase "Heaven, Hell or Hoboken." They knew they would either die and go to one of the first two places or survive and make it back to the third and begin the rest of their lives. For the 116,000-plus who died overseas, Hoboken was the last piece of land they stood on in America. (Courtesy of HHM.)

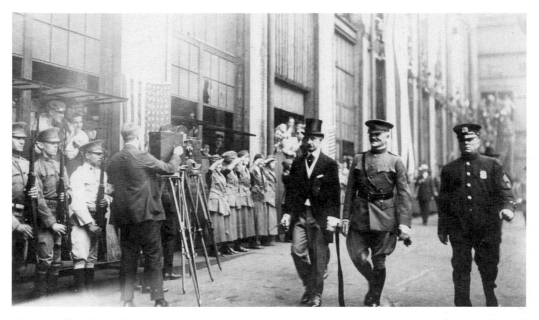

General Black Jack

The soldiers who survived the war did return via Hoboken, including Gen. John "Black Jack" Pershing, commander of the American Expeditionary Force. This photograph shows Pershing, center, in Hoboken upon his return on September 8, 1919. To the left of him is Rodman Wanamaker, a department store magnate who supposedly bought more war bonds than any other American and who presided as emcee for numerous victory parades. Besides Pershing, other famous American veterans who almost surely passed through Hoboken include future president Harry S. Truman, comedian Buster Keaton, baseball player Ty Cobb, movie producer Darryl F. Zanuck, and World War II luminaries Dwight D. Eisenhower, Douglas MacArthur, and George S. Patton. (Courtesy of HHM.)

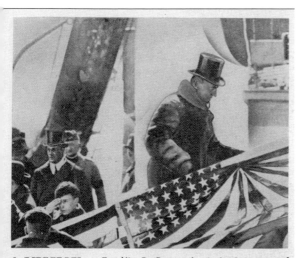

A MISSION — Franklin D. Roosevelt, Ass't. Secretary of the Navy, watches President Woodrow Wilson climb the gangplank of S.S. George Washington at a Hoboken pier as he sails for Paris Peace Conference on December 4, 1918. Armistice had come to the world a month before he sailed.

Presidents Abound

During World War I, even presidents left for Europe via Hoboken. This image shows Pres. Woodrow Wilson boarding the USS *George Washington*, a ship the federal government confiscated from one of Hoboken's German shipping lines. Wilson left on December 4, 1918, on his way to the Paris Peace Conference, where the Allies would negotiate the terms of Germany's surrender and where Wilson would lobby for the establishment of a peace-promoting, though ultimately toothless, League of Nations. Wilson later returned to Hoboken for a victory parade along Washington Street on July 8, 1919. The man wearing the top hat on the left side of the photograph is Franklin Delano Roosevelt, then the assistant secretary of the Navy and future US president. (Courtesy of HHM.)

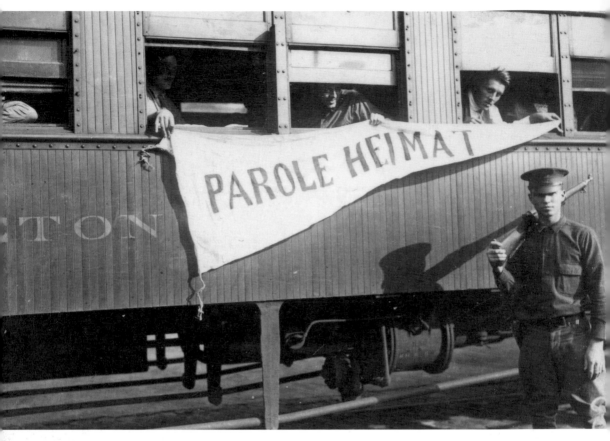

Little Bremen No Longer

During the war, Germans in America felt persecution nationwide, and especially in Hoboken, where at least a quarter of the residents were German, the school system taught classes in German, and the city had a nickname of Little Bremen. The federal government feared sabotage, so when it took control of the waterfront, it fired all the German workers. Many German businesses had to close, and many German residents felt compelled to leave the city. The ones who stayed watched trains enter the city with enemy aliens like the ones in this photograph. The government shipped hundreds of prominent Germans in America from Hoboken to an internment camp on Ellis Island, including the Reverend Hermann Brückner of Hoboken's St. Matthew Trinity Lutheran Church. (Courtesy of HHM.)

Marie

Julius Durstewitz's wife, Marie, formerly Szontag, worked as a nurse when she was a young woman, possibly for the city's health or recreation departments. Here she is standing in an unidentified playground. She also taught sewing and other domestic skills at the city's recreation center on Second and Jefferson Streets. (Courtesy of HHM.)

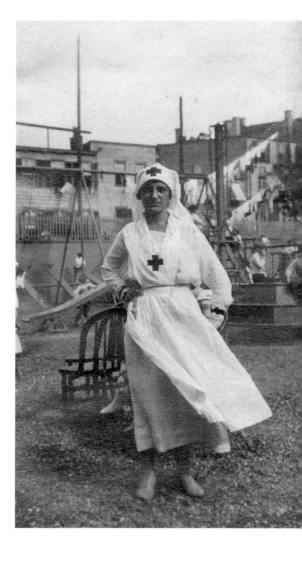

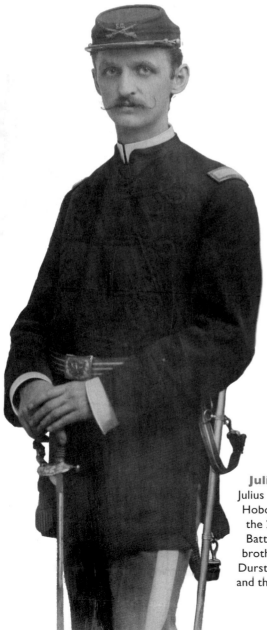

Julius

Julius Durstewitz had a long career as a public servant in Hoboken. As a young man seen here around the turn of the 20th century, he served as a captain in the Stevens Battalion, attached to the Army National Guard. His brother George served as a captain in the same unit. Julius Durstewitz supervised the battalion's calisthenics program and the fife and drum detail. (Courtesy of HHM.)

Recreation for Everyone

Julius Durstewitz became Hoboken's director of parks sometime around 1913 and promoted exercise and recreation among the city's residents. He posed for this photograph in May 1916 with the students of a calisthenics class he taught at the Our Lady of Grace School. The woman seated to his right is his wife, Marie. During his tenure as parks director, Durstewitz supervised construction of the county-built Columbus Park on Ninth and Clinton Streets. (Courtesy of HHM.)

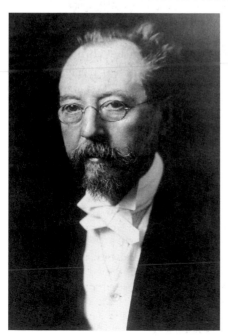

Depicting the Ships

It fits that a city famous for ships should produce an artist famous for making paintings of ships. Antonio Jacobsen was born in Copenhagen and came to America in 1873. He painted more than 6,000 portraits of ships, often taking commissioned requests from Hoboken's captains, sailors, and ship owners. Jacobsen's work has appeared in the National Museum of American History and the Mariners' Museum in Newport News, Virginia. (Courtesy of HHM.)

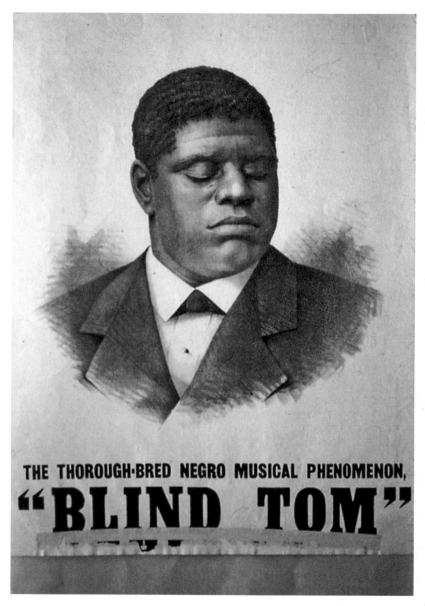

THE THOROUGH-BRED NEGRO MUSICAL PHENOMENON,
"BLIND TOM"

Blind Tom

Thomas Wiggins was born blind and as a slave in Georgia in 1849, but he died in 1908 as a nationally popular entertainer who lived in Hoboken. Because of his blindness, Wiggins was spared forced labor in the fields. He had more leeway to roam around the plantation, and he discovered the piano at an early age. He had a natural ear for music. Wiggins's slave owner, lawyer and Confederate general James Bethune, began sending the boy with a tour promoter to perform at stops across the United States. After the Civil War and emancipation, Bethune continued to manage Wiggins's career, taking him on a tour of Europe. Audiences praised Wiggins's showmanship, and music experts marveled at his ability to master songs quickly. Wiggins lived with various members of the Bethune family during his entire life, eventually dying in Hoboken while living on Twelfth and Washington Streets with the divorced wife of James Bethune's son John. The Bethunes had waged a long, interfamily legal battle to decide who among them would get to control Wiggins's lucrative career. (Courtesy of HHM.)

Cheapskate Hetty

One of history's greatest misers hoarded her money while living part-time in a modest flat at 1203 Washington Street in Hoboken. Hetty Green, born in 1834 into a Massachusetts Quaker family, inherited $7.5 million from her deceased father's whaling business in 1864. Though she married a man from a relatively wealthy family, Green worked to add to her own fortune by investing in government and rail bonds, stocks, and real estate. Her conservative investing strategy shaped her stinginess with money, and she became famous for quarreling with her staff and shopkeepers for even the most trifling amounts. Legend has it that when her son broke his leg she tried to get him treatment at a free clinic rather than pay for care. Numerous reports say she routinely skimped on meals, clothing, heat, and even soap. Green's fellow investors dubbed her the "Witch of Wall Street," though she always managed to avoid the wild ebb and flow of investing. When she died in 1916, she left of a fortune upwards of $3.8 billion dollars in today's rate. (Courtesy of the Library of Congress.)

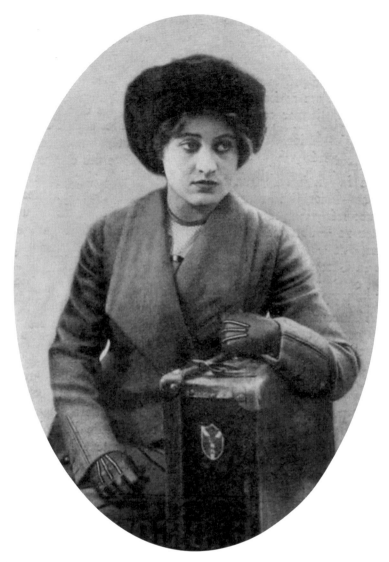

A *Titanic* Star

The fact that Dorothy Gibson was born in Hoboken on Willow Avenue in 1889 happens to be the only mundane detail of her disaster-riddled life. She was a famous stage and silent film actress and *Cosmopolitan* cover model when she survived the sinking of the *Titanic* in 1912. She starred and played herself in a movie about the disaster, *Saved from the Titanic*, which opened in theaters just weeks after the actual event. Gibson suffered a nervous breakdown soon after and retired from acting. No known copies of the movie exist. Gibson's life only got worse after the breakdown. While driving in 1913, she accidentally killed a pedestrian, and she faced scandal during the ensuing trial when the public learned of her role as mistress to the car's married owner. Gibson later married her lover, a movie star executive, though a court ruled the marriage void after only two years. It was her second divorce. Gibson then fled to Europe, where she eventually became a Nazi sympathizer. She then had a change of heart, leading to her arrest and imprisonment in Italy as an anti-Fascist dissident. She soon escaped from prison with a journalist and a general thanks to the help of the archbishop of Milan and the local resistance group. When the war ended, she moved into the Ritz Hotel in Paris but died of a heart attack a year later at the age of 56. (Courtesy of the Randy Bryan Bigham Collection.)

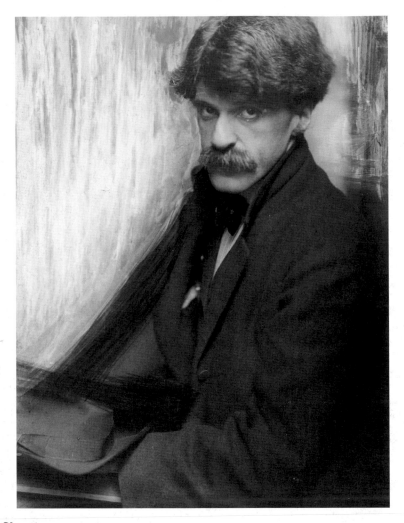

Stieglitz Shoots

Photographers everywhere should thank Alfred Stieglitz for popularizing their medium. Stieglitz was born in Hoboken in 1864 to German immigrants. His father had been an officer during the Civil War and a wealthy businessman in wool manufacturing. In his teen years, Stieglitz attended private schools in American and in Europe. Though he originally studied mechanical engineering, he discovered photography in the 1880s and then devoted his life to taking pictures. After returning to America in the 1890s, Stieglitz edited a newsletter for the Camera Club of New York, an association of amateur photographers. As an expert and critic, Stieglitz promoted more professional standards, arguing that photography could rise to be the aesthetic equal of painting and other arts. In 1902, Stieglitz formed a new group, the Photo-Secession, and positioned it within the larger art community. He associated with Pablo Picasso, Auguste Rodin, and other artists. After World War I, Stieglitz led photography's entrance into the modernist movement, encouraging photographers to capture the rapid pace of modern life. From the 1920s to the 1940s, he highlighted the best work of his fellow photographers in the series of three art galleries he ran in New York. Stieglitz summarized his life and work during a 1921 exhibit by writing, "I was born in Hoboken. I am an American. Photography is my passion. The search for Truth my obsession." Stieglitz, who died in 1946, was married to the noted painter Georgia O'Keeffe. His photographs of O'Keeffe, numbering in the hundreds, have become a celebrated collection in the history of the medium. (Courtesy of the Library of Congress.)

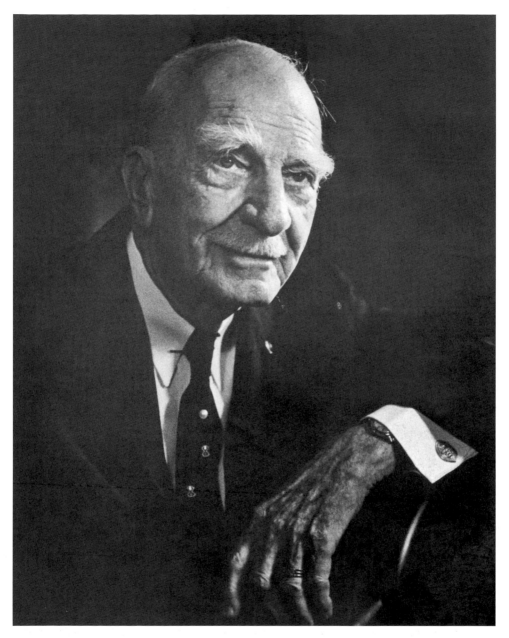

General Motors Mott

Some students at Stevens Institute of Technology have gone on to do some impressive things. One of them, 1897 graduate Charles Stewart Mott, cofounded what became the biggest company in the world. Soon after graduating from Stevens, Mott inherited leadership of his father's bicycle company. He moved it to Flint, Michigan, where through a series of mergers, he became one of General Motors' founding partners in 1908. Mott served on the company's board of directors for more than 60 years. He used his vast wealth from the booming automobile industry to better his community. He founded the current Charles Stewart Mott Foundation in 1926, which has donated to schools, hospitals, and other causes in Flint and elsewhere. Mott also served two terms as mayor of Flint and ran for governor of Michigan in 1920. (Courtesy of the Charles Stewart Mott Foundation.)

The Poverty Photographer

Famed Depression-era photographer Dorothea Lange was born in Hoboken at 1041 Bloomfield Street in 1895. A third-generation German, she dropped her father's last name, Nutzhorn, and took her mother's maiden name after her father abandoned the family. As a child, Lange battled polio, which left her with a permanent limp in her right leg. She later studied photography at Columbia University. During the 1930s, Lange got a job documenting the Great Depression for the federal government. Several of her photographs have become iconic images of the era's poverty and desperation. She later took striking images of Japanese American internment camps during World War II. Lange also taught at the California School of Fine Arts and cofounded a photography magazine, *Aperture*, which is still in print. Lange, who for a time was married to the noted painter Maynard Dixon, died in 1965. She was inducted into the California Hall of Fame in 2008. (Courtesy of the Library of Congress.)

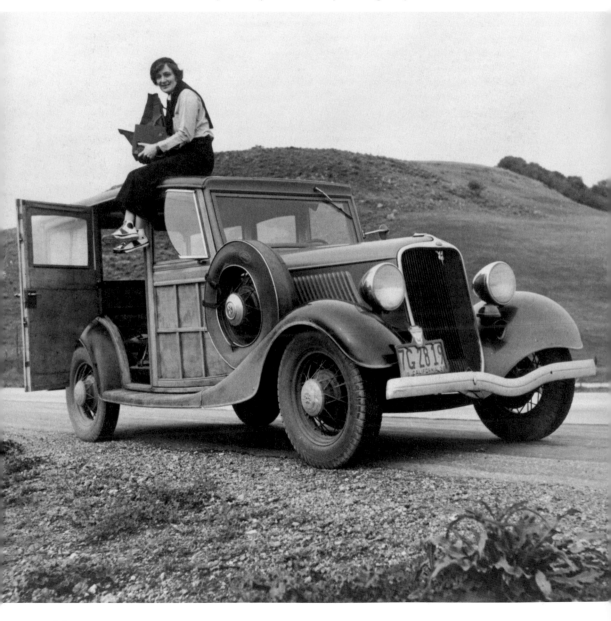

The Sex Scholar

Alfred Kinsey, the founder of American sexology, was born in Hoboken in 1894. His father, a machine shop professor at Stevens Institute of Technology, could not afford enough care for the family, so Kinsey developed illnesses such as rheumatic fever and typhoid fever. Kinsey's father was also a strict Methodist who insisted on taking the family to church several times each week. Kinsey later devoted his career to shattering such reverence. Kinsey, who studied biology at Bowdoin College and Harvard University, turned from observing wasps to surveying Americans about sexuality. Though his 1948 and 1953 books *Sexual Behavior in the Human Male* and *Sexual Behavior in the Human Female* shocked conservative audiences, the books greatly expanded the medical community's knowledge of sexual behavior and helped inspire later movements toward sexual liberation. Though Kinsey died of pneumonia in 1956, the Kinsey Institute for Research in Sex, Gender, and Reproduction at Indiana University continues his work. (Courtesy of the Kinsey Institute for Research in Sex, Gender, and Reproduction; photograph by William Dellenback.)

The Plumber

No biography of G. Gordon Liddy can omit his role in supervising the Watergate scandal and his subsequent prison term. But before he got mixed up with Richard Nixon, Liddy grew up in Hoboken during the 1930s. He had a German nanny, and he attended nursery school at Stevens Institute of Technology. Though he was sickly as a child, Liddy would later boast of roasting and eating a rat to prove his fearlessness. Liddy served as an artillery officer in the Army and graduated from the Fordham University School of Law. He then joined the FBI, eventually earning the rank of supervisor, but left the bureau to practice law. He worked in the Nixon administration and later on the president's reelection campaign, where Liddy led the "plumbers" responsible for securing political leaks. After the break-in at the Democratic National Committee office at the Watergate Hotel in Washington, DC, Liddy was convicted of burglary, wiretapping, and conspiracy, resulting to a 20-year sentence. Pres. Jimmy Carter shortened Liddy's sentence, and since leaving prison in 1977, Liddy has written an autobiography, acted, and hosted a radio show. (Courtesy of the National Archives.)

CHAPTER TWO

Street Names

First there were the Native American tribes who hunted and fished in the land along the Hudson. Then, the plucky Dutch came, with big plans for a grand colony, but the British soon followed and forced the Dutch back to Holland. After a hundred or so years, the British evolved into the Americans, who began making declarations and dividing the land into streets. Once the buildings went up, the Germans and Irish came to live in them. After the first big war, a lot of the Germans left, and the Italians replaced them. The Puerto Ricans came during the 1950s, and then more Irish came during the 1980s. Some say the yuppies are the ones coming now, but that's another story.

Hoboken has long been a melting pot, though sometimes the groups in the pot have fought each other. There was a large nativist riot against parading Germans on May Day in 1851, and in 1909, a mostly Irish police force exchanged gunfire with a mass of Italians who were upset over the accidental death of a small boy. The Irish and Italians maintained a territorial rivalry well into the 20th century, with Willow Avenue separating the western residing Italians from the rest of the city. Crossing the wrong street could result in a fistfight.

Things are better now, of course. Besides the big groups there have been sprinkles of others, including Scandinavians and Slavs. Washington Street currently boasts restaurants featuring Chinese, Japanese, Thai, Greek, Indian, and Middle Eastern food. The city hosts festivals, parades, and cultural events to celebrate its Italian, Irish, German, and Puerto Rican roots. Even people whose families have been in America for generations still appreciate celebrating their ethnic heritage. Everyone seems to attend everyone else's event too. Longtime residents say that "old" Hoboken is ethnically diverse, but that together they have become one Hoboken.

In Hoboken there are street names—Hudson, River, Washington—and then there are street names—Stick, Memo, Proc—the nicknames people carried when they were growing up in the old neighborhoods. It is still common to hear a grown man yell to another man across the street and address him using a nickname from decades ago. Something like "Hey, Pupie!" is a common exclamation.

Leonore

At the time of this photograph around 1900, the little girl on the left holding a doll, Leonore Toepfer, lived with her German-born parents, Carl and Lisbet, and her two brothers and one sister, a typical German family in Hoboken. But soon after, she married businessman John Muller and became the matriarch of a great Hoboken family. Their son Roger kept the family insurance business going, and it is now in the hands of Leonore's grandchildren Roger Jr. and Erika. (Courtesy of HHM.)

Judge Koch

Henry Koch was one of many Germans in Hoboken who took a leadership role in the city. Koch began serving as a justice of the peace in 1907, and he also served as a notary public and as the city's commissioner of deeds. Koch ran a business from an office at 205 Washington Street that made travel arrangements for shipping and rail lines. (Courtesy of HHM.)

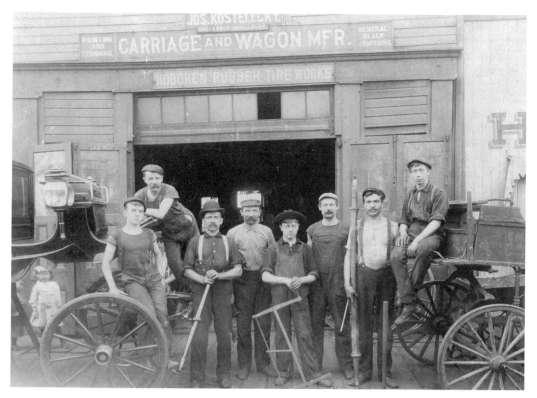

The Kostelecky Family

Czech-born Joseph Kostelecky, fourth from the left in the derby hat, came to Hoboken in the 1880s and started a business at 218 Bloomfield Street that evolved from a repair shop for horse-drawn carriages to a mechanic for gas-powered cars. Kostelecky married twice and fathered nine children, some of whom joined the family business. His son Frederick kept it going until he retired in the 1980s. (Courtesy of HHM.)

Reverend Hermann

Hermann Brückner had been serving as reverend of the Church of St. Jacob in Weimar, Germany, in 1907 when representatives of the German Seamen's Mission recruited him to lead its newly opened Seamen's Home at 64 Hudson Street in Hoboken. The following year, Brückner arrived, and he served at the home for almost 50 years. He ministered to the thousands of German sailors in the area, including those working for the Hamburg-American, North German Lloyd, and other companies in Hoboken. (Courtesy of HHM.)

An Enemy Alien

Just after the Seamen's Home expanded in 1914, World War I erupted. More than 10,000 sailors around New York were stranded, unable to return home even on neutral ships. Germans in America faced suspicion and persecution. Things got worse for them after the United States entered the war. On Good Friday in 1917, the federal government arrested Hermann Brückner under suspicion that he would aid the enemy. He and hundreds of other Germans were sent to an internment camp on Ellis Island. Brückner would later write that the guards were startled when the other prisoners put him on their shoulders and carried him to his cell. The government held Brückner for seven months but released him when it found no evidence of wrongdoing. The Seaman's Home again became a target during World War II. Brückner had mixed feelings. He was loyal to his native Germany but wary of the government there. He wrote at the time, "Then came the time of bewilderment, 1933 to 1945. We on the outside, our hearts broken, felt we must somehow stand by Germany. But we couldn't; nor should we have violated our duty to the country that had become our home. We were suspected, arrested, released, placed under observation as 'enemy aliens.' But God's help led us, chastised but alive, through that bleak time." The government arrested some of the sailors, though not Brückner, and pressured the Seamen's Home financially until seizing it entirely by the end of the war. After the war, the home could operate again, but it took several years for German shipping to rebound, and by then, the ships were coming instead to the larger and more modern ports of Newark and Elizabeth. The Seaman's Home in Hoboken continued for a few years more, mostly as a retirement home. The organization still operates but no longer in Hoboken. (Courtesy of HHM.)

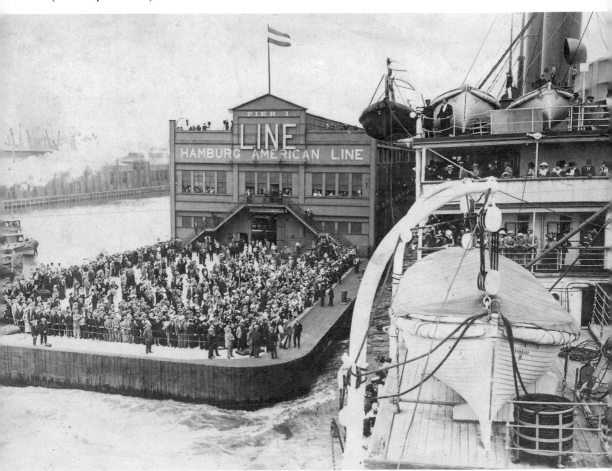

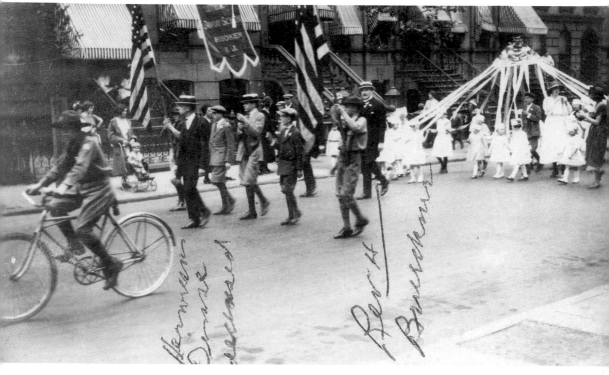

Evening in Hoboken

In 1914, Brückner became reverend at the St. Matthew Trinity Lutheran Church at 57 Eighth Street. He presided over baptisms, weddings, funerals, and other occasions, such as this 1923 midsummer maypole parade. Brückner served as reverend at St. Matthew until his retirement in 1957. He was a literate man. Besides German, he spoke English fluently. He earned a doctorate in theology from the University of Jena in 1925 and published two collections of stories he collected from the German sailors. He wrote several poems, including this one about his adopted homeland, titled "Evening in Hoboken:"

> Across the river / flood waves of people / on fast white boats / thousands upon thousands / and always more / the army of work pushes home / tired people: no dream of victory / livens their hearts / their souls ask only / not to be defeated / to how many does life grant this wish? / A day like all others / pressing cares / weigh on today, on tomorrow / all eyes on one thing / all minds with one thought: the yellow metal! / the only hope they know / to escape life's troubles / and at the end, betrayed / they have simply pulled their master's cart. // They do not see / what pours from heaven / how beauty flows from supernatural springs / how the narrow world widens / the earth: transient / the giant city: a fortress no longer / the greater eternity all around / telling us: you can't be constrained forever / only will it / and you'll take flight // They talk, stare, tired and flat / blinded by the heavens' glow / turning away from the golden light / they don't understand the language of the universe / alien the sun from which they sprang / alien the earth on which they walk / a poor people, a forlorn generation / they've lost their goal, thrown away their right.

The poem has a cynical, critical, and sad tone. Perhaps Brückner battled sadness his entire life. Two days after he retired, he committed suicide. (Courtesy of HHM.)

Young Blue Eyes

This young man later sang "Summer Wind" and "My Way" and starred in *Ocean's 11* and *The Manchurian Candidate*, among many other beloved performances. Frank Sinatra was born at 415 Monroe Street on December 12, 1915. His father, Antonio, emigrated from Palermo in 1903 and later worked as a Hoboken city firefighter. Sinatra's mother, Natalie, went by the name Dolly and was very active socially. Sinatra was an only child. He never finished school and instead worked as a delivery boy and on the docks before catching his big break as a singer. (Courtesy of HHM.)

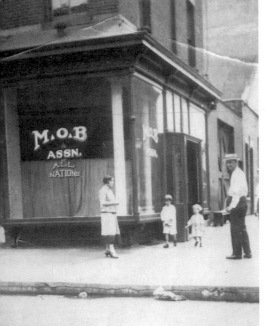

Marty O'Brien's

Frank Sinatra's father, Antonio, fought as a lightweight boxer. But he couldn't fight under his own name, because many promoters in those days refused to sponsor Italian boxers, so he fought under the Irish name Marty O'Brien. After he retired, Sinatra opened a bar on Jefferson Street that he named Marty O'Brien's. He gave it a subtitle, An Association of All Nations, meaning he would welcome anyone regardless of their ethnic background. Though the original M.O.B. is closed, the owners of a bar on First and Bloomfield Streets have revived the name. (Courtesy of HHM.)

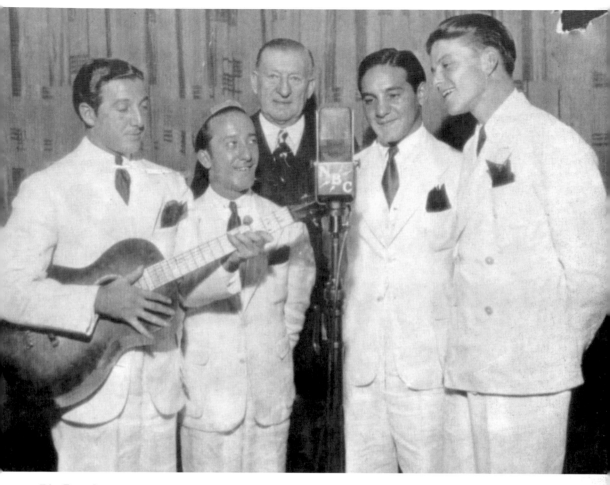

Big Break

Sinatra caught his big break when he joined the Three Flashes, a local singing group that included James "Skelly" Petrozelli, Pat "Patty Prince" Principe, and Fred "Tamby" Tamburro. Legend has it that Sinatra's mother, Dolly, pressured Tamburro's mother to get him to ask Frank to join. After adding Sinatra, the group changed its name to the Hoboken Four and won a singing contest on the popular *Major Bowes Original Amateur Hour* radio program in 1935. The group then went on tour, but Sinatra was becoming a bigger star than the other three and left for a solo career. (Courtesy of HHM.)

Hoboken's No Longer

It seems Sinatra was famous by the time he posed for this photograph sometime in the late 1930s, likely at St. Francis at 308 Jefferson Street, the family church where he was baptized. Dolly Sinatra is the woman in front wearing a black coat. Hoboken gave Sinatra a ceremonial key on October 30, 1947, and soon after, Sinatra had his biggest break of all, with his home city. By that time, he belonged to Hoboken no longer. Sinatra would spend the rest of his life in Palm Springs, Las Vegas, and Manhattan. He went from being Frank from the neighborhood to leader of the Rat Pack and lover to Ava Gardner and Marilyn Monroe. He cavorted with mobsters and hobnobbed with presidents. By many accounts, the ambitious Sinatra came to resent provincial Hoboken and deny he was from there. Records suggest he returned only twice after the key ceremony, once in 1948 and then not until 1984. (Courtesy of HHM.)

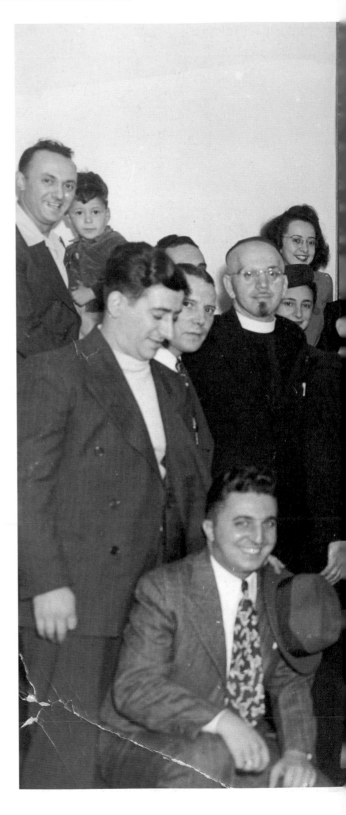

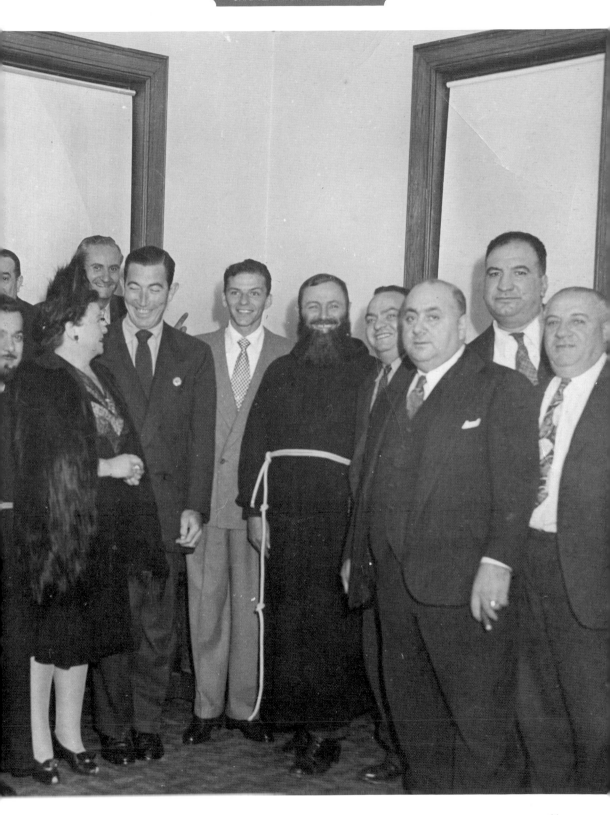

Little Jimmy

Frank Sinatra wasn't the only famous singer from Hoboken. Jimmy Roselli, far right, had his own successful music career. He was born in 1925, but his family life fell apart soon after. His mother died after giving birth, and his father abandoned him. Roselli lived with his grandfather, who worked on the docks and only spoke Italian, and four aunts. Roselli worked as a shoeshine boy, but by age nine, he was performing in Hoboken's clubs, and at 13, he caught his big break just like Sinatra did, by winning the *Major Bowes Original Amateur Hour* radio contest. (Courtesy of HHM.)

The Other Famous Singer from Hoboken

A tenor whose emotion onstage contrasted with Sinatra's cool, Jimmy Roselli performed on *The Ed Sullivan Show* and at the legendary Copacabana Club. His biggest hits were "There Must Be a Way," "All the Time," and "Please Believe Me," all of which reached the Top 30 on the Billboard easy listening chart. He was also famous for the Neapolitan songs "Come Back to Sorrento" and "Bad Woman," which he sang in Italian. Like Sinatra, Roselli also mingled with mobsters. He was friends with Carlo Gambino and sang at the wedding of John Gotti's son. But Roselli's career stagnated due to his abrasive personality and mistrust of the entertainment business. He declined appearance requests from popular venues like *The Tonight Show* and a role in *The Godfather Part II*, but he did enjoy a renaissance later in life, performing in Atlantic City for as much as $100,000 per night. Roselli died at 85 in 2011. (Courtesy of HHM.)

Poolshark Ralph

Ralph Riccio's father Michael was a successful real estate businessman who supposedly bought the first automobile in Hoboken. The younger Riccio was entrepreneurial himself and opened a tavern at 634 Grand Street when he was just 17 years old. He ran it for 10 years until the government closed it during World War I. The bar was only one block east into the dry zone. Riccio then opened a pool hall that he ran for 30 years. Frank Sinatra, who was friends with Riccio's son Mike, was a frequent guest. Riccio raised eight children with his wife, Rose. He later ran a small candy store under his home at 612 Grand Street. He died at age 77 in 1966. (Courtesy of HHM.)

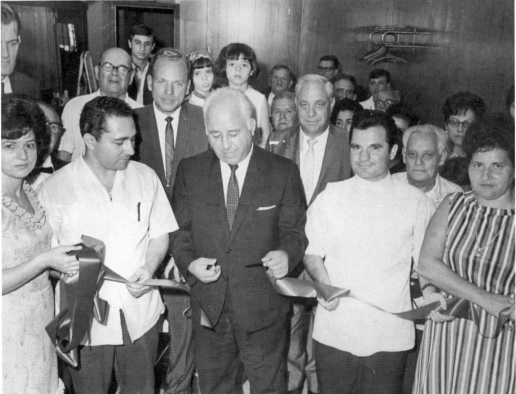

The Lisas

This photograph shows a 1966 ribbon-cutting ceremony celebrating the grand opening of D&V Barbershop, which still operates at 1032 Washington Street. At center is Mayor Louis De Pascale. On De Pascale's right is Dominick Lisa, and on De Pascale's left is Vincent Pasquale. Now retired, they were the "D" and "V" of the shop. The tall, young man in the back, behind the man wearing glasses, is Anthony Lisa, who now runs the Lisa family's other Hoboken business, Lisa's Deli at 901 Park Avenue. (Courtesy of HHM.)

Biggie
Joseph "Biggie" Yaccarino emigrated with his parents from Naples when he was an infant. He was one of 12 children. During the 1930s, he rose to local fame performing as a comedic entertainer for parties and festivals. But it was his second career as a restaurateur that truly made him a Hoboken legend. (Courtesy of HHM.)

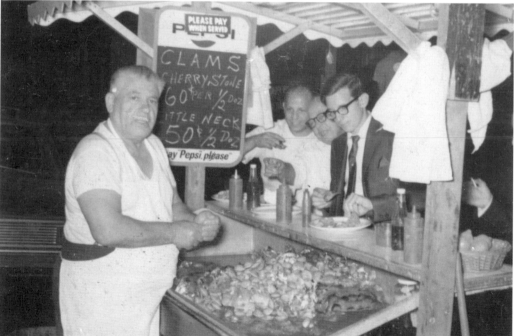

The Clam Man
After he stopped dressing up and telling jokes, Biggie Yaccarino turned to selling clams. He started in 1941 by pushing a cart and selling half-shell clams for a nickel each, and by 1946, he had saved enough money to open a restaurant, Biggie's Clam Bar at 318 Madison Street. (Courtesy of HHM.)

Biggie's Today

Biggie and his wife, Rose, had seven children. Their son Michael "Brother" Yaccarino started helping his parents and inherited the business in 1965. Brother and his wife, Marie, married in 1958 and had two daughters, Rose Marie and Judy. Rose Marie, in this photograph, and her husband, Steve Ranuro (not pictured), have run the Biggie's empire since 1996. They now have five locations. The original on Madison Street still stands. In 2010, the Ranuros opened a second location in nearby Carlstadt, a third with the help of extended family in Kingsport, Tennessee, a fourth in Hoboken in 2012, inside the famous former Clam Broth House at 42 Newark Street, and a fifth nearby in Ramsey in 2013. Rose Marie and Steve hope to pass the business to their sons, Steven, here with his mother, and Michael, and extend the legend of Biggie's into a fourth generation. (Author's collection.)

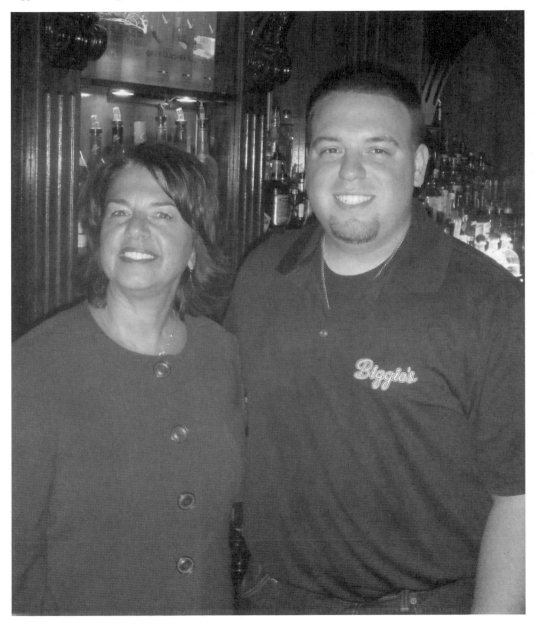

Pepe the Pioneer

All 12-year-old Maria Pepe wanted was to play baseball for her local Little League team. She did get to pitch in three games for Hoboken's Young Democrats team in 1972, but the national Little League office opposed letting girls play and threatened to revoke the Young Democrats' charter. The National Organization for Women filed a lawsuit on Pepe's behalf. The New Jersey Superior Court ruled in Pepe's favor two years later, but by then, Pepe was too old to play. Still, the case forced the Little League office to accommodate female players. Pepe went on to earn a master's degree and work in accounting for the nearby Hackensack hospital. The Little League office eventually reconciled with Pepe, inviting her to throw a ceremonial first pitch during the 2004 Little League World Series and displaying her glove in its museum. Pepe's case opened the door for girls everywhere. By 1974, more than 30,000 girls were playing, and over 250,000 are playing Little League baseball today. (Courtesy of HHM.)

Chef Pepe

Maria Pepe isn't the only notable member of the Pepe family. Her cousin Rich Pepe is a successful restaurateur in California. He owns four Italian restaurants in Carmel and Pebble Beach, plus two bakeries, two wine brands, and a line of pasta sauce. Both sets of Pepe's grandparents came from southern Italy before World War I. His father was one of eight children, including a brother who is Maria Pepe's father. While he was growing up, Pepe's large extended family would gather to eat, make wine, and sing Italian songs. "I could only imagine that this is what life was like in Italy and was proud that my family brought a little bit of the old country with them to America," Pepe has said. (Courtesy of Rich Pepe.)

Joey Pants

Decades before he won an Emmy for his role as mobster Ralph Cifaretto on HBO's *The Sopranos*, actor Joe Pantoliano was just another kid from the neighborhood, one who everyone called by his street name, Joey Pants. Pantoliano grew up poor. During a 2010 dinner honoring him in Hoboken, Pantoliano talked about what he learned with "the gift of poverty." Later that night, Pantoliano became emotional when he got to meet the family that is currently living in the housing project home Pantoliano's family used to occupy. Pantoliano has had a successful career as an actor, with roles in popular movies such as *The Matrix, Memento, The Fugitive,* and *The Goonies.* Offscreen, he has become a spokesman for mental health since admitting his own battle with depression. He has created a foundation to raise awareness called No Kidding, Me Too. Pantoliano has written two memoirs, titled *Who's Sorry Now: The True Story of a Stand-Up Guy,* and *Asylum: Hollywood Tales From My Great Depression.* He is also a partner in his friend Rich Pepe's sauce line, which they call Pepe & Pants and have given a tagline of "Two guys from Hoboken." Pantoliano lives in Connecticut but still keeps a home in Hoboken. (Courtesy of Joe Pantoliano.)

Proc

Michael Russo doesn't remember exactly how his friends in Hoboken came to call him "Proc," or even what it means, but he still hears it sometimes. Russo is the son of former mayor Anthony Russo and cousin to city councilmember Theresa Castellano. Michael Russo grew up serving in Hoboken's Boy Scout Troop No. 146 and later starred as a tight end and defensive lineman at Hoboken High School. After graduating, Russo served as a football coach for the Police Athletic League. He currently works as a physical therapist and has donated his time to help Hoboken's student athletes heal. Russo followed his father's political footsteps by winning election to the Hoboken City Council in 2003, and he was most recently reelected to a four year term in 2011. He lives with his wife, Lisa, and their daughter, Lia Grace. (Author's collection.)

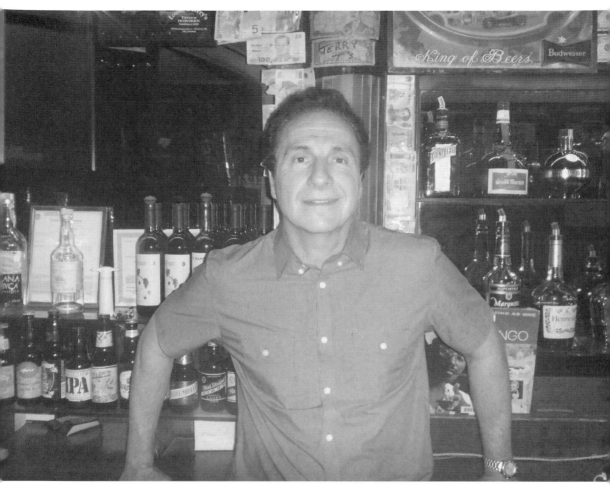

Stick

Anthony "Stick" Romano got his street name from playing stickball on the playground of Wallace Elementary School. Romano's grandparents emigrated from Italy. His father was a police officer. Romano grew up on Tenth Street and Willow Avenue and had a job pumping gas by age 13. After college at St. Peter's University in Jersey City, he worked as a history teacher at Hoboken High School, and, in 1978, he followed his father's footsteps by joining the police department. Romano retired as a captain in 2011 but continues to serve Hoboken as its freeholder, or elected representative, in the Hudson County government. He also served on the Hoboken Board of Education and has taught criminal justice at St. Peter's. Amiable and attentive, Stick often spends time in his civic association office on Washington and Third Streets or inside Louise & Jerry's, the Washington Street bar he inherited from his aunt Louise and uncle Jerry. (Author's collection.)

Pupie

"I was my mother's little Pupie from the day I was born," Frank Raia remembers about how he came to get his nickname. Gregarious and grandiose, Raia has had a towering presence in Hoboken since the 1960s. He was a multi-sport star at Hoboken High School, where he remembers competing regionally against future Oakland Raiders star Jack Tatum. Raia was the second youngest of six children born to a single mother. By age 12 he was working on a milk truck, and by 16, he was working in a textile plant. He was soon promoted to salesman and increased the company's revenue exponentially. In the late 1970s, Raia turned to real estate. He built his first affordable housing unit in Hoboken in 1980 and has built over 500 throughout New Jersey. Raia also developed the Clearview cinema and ShopRite grocery in Hoboken. Raia has served on the Hoboken City Council and Board of Education and on the North Hudson Sewage Authority. He has also served as a trustee for the nonprofit HOPES Community Action Partnership and the HoLa Dual Language School. Raia has one biological son with his wife Karen, plus an adopted nephew and two foster children. Every summer, he throws himself a birthday party on the waterfront and invites the entire city, treating all to food, drinks, and music. (Author's collection.)

Young Matriarch
For more than 50 years, Joan Smith Cunning lived in the southern row of Willow Terrace, the two rows of quaint houses between Sixth and Seventh Streets and Clinton Street and Willow Avenue. As a child, she lived with her firefighter father, homemaker mother, and seven siblings. She would later start her own family, one that has had a big impact on Hoboken's Irish community and the city as a whole. (Courtesy of HHM.)

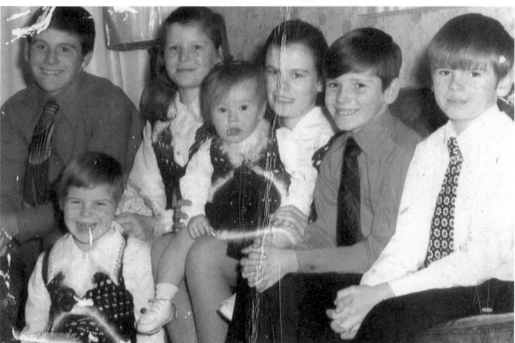

The Cunning Kids
The former Joan Smith married warehouse worker Eddie Cunning in 1955. They moved into another house in the Terrace and had seven children: from right to left, Edward, Helen, Joaneileen, Bernadette, John, and Dan, with Janemarie in front. John and Dan eventually joined the Hoboken Fire Department, and Edward became a police officer. (Courtesy of HHM.)

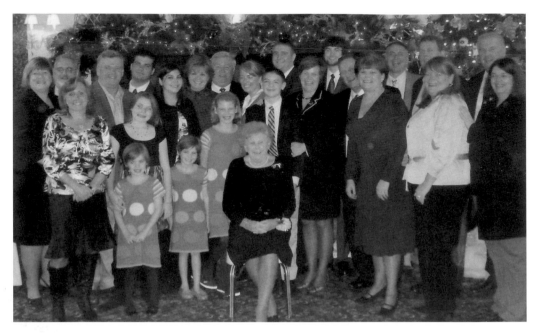

The Cunnings Today

On their maternal side, the Cunnings' roots in Hoboken date to 1888, when Joan's grandmother Bridget Connolly came to Hoboken from County Mayo and got a job as a maid for a wealthy widower whom she later married. The Cunning children have embraced their Irish heritage and have shared it with the entire city. The family helped found the Hoboken St. Patrick's Day parade down Washington Street, which drew tens of thousands of tourists every year before going on hiatus in 2012. (Courtesy of HHM.)

Grand Marshal Bill

As someone proud of his Irish heritage, Bill Noonan was honored to serve as grand marshal of the 2011 Hoboken St. Patrick's Day parade, one that drew an estimated 25,000 visitors. Noonan has acted and tended bar, most recently at the famed rock and roll club Maxwell's, and he now works for a technology firm in Hoboken. Noonan has been a member of the Hoboken Elks Lodge No. 74, served as a commissioner on the Hoboken Housing Authority and on the board of the Hoboken Charter School, and helps organize the city's annual Memorial Day parade. (Author's collection.)

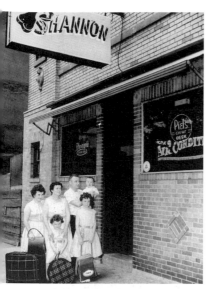

Irish Row

The Shannon is one of Hoboken's oldest bars and a staple of "Irish Row," the cluster of Irish-themed bars on First Street near city hall. Michael and Johanna Wall, who came from County Limerick, opened the bar in 1956. The husband and wife, seen here with their children, passed on the business to their daughter Marie, who still runs it today with her daughter Tara. (Courtesy of Tara Whelan.)

La Borinquena

Since 1966, Hoboken's Puerto Rican community has raised its home island's flag on the pole at city hall. Raul Morales, left, and his son Raul Jr. have served as presidents of the Puerto Rican Culture Committee. Besides the flag-raising every summer, the committee honors a notable Hoboken resident of Puerto Rican heritage, gives scholarships to graduating high school seniors, hosts a luncheon for the community's senior citizens, and leads the entire community in singing the Puerto Rican national anthem, "La Borinquena." The elder Morales works as a vice president for the Applied Development Company, and the younger Morales, a graduate of Hoboken High School, works as a lawyer. (Author's collection.)

Memo

"They called me Memo as a kid because I had a good memory and I was giving people memories," Carmelo Garcia has said about his childhood nickname. Though the buoyant Garcia can reminisce with a wide smile, he can also remember a childhood filled with tragedy. He lost his home in an arson-suspected fire, one of several that terrorized Hobokenites during the late 1970s. Fires between 1978 and 1981 alone killed 41 people, including 30 children. No one was ever arrested. Many in the city still suspect greedy landlords and developers hired arsonists so that they could easily destroy low-income buildings and replace them with more lucrative luxury units. Garcia spent the rest of his childhood growing up in the Hoboken Housing Authority, the federally subsidized cluster of buildings in the city's southwest corner built to shelter Hoboken's poorest residents. Like many projects, the one in Hoboken could be difficult and dangerous. Many of Garcia's contemporaries struggled to break the cycle of poverty. But Garcia was determined to succeed. He worked hard at school and continued his education. He earned a degree in criminal justice from Seton Hall, a graduate degree from Stevens Institute of Technology, and certificates from Cornell and Rutgers. After starting his career in banking, Garcia turned to public service. He served as president of the Applied Housing Tenant's Association, and in 2001, he was the first Hispanic head of a municipal agency in Hoboken, serving as director of health and human services. From 2002 to 2014, Garcia was an elected trustee of the Hoboken Board of Education, including serving as its president. In 2007, Garcia reached the most meaningful point in his career when he was hired as executive director of the Hoboken Housing Authority, the first current or former resident to serve as director. In 2013, he was elected to one of two seats in the State Assembly representing the 33rd legislative district. Garcia continues to live in Hoboken with this wife and three children. (Courtesy of Carmelo Garcia.)

CHAPTER THREE

City of Industry

Since the Stevens family's heyday, Hoboken has been a transportation hub. The city had interstate railroads and international shipping lines beginning by the mid-19th century. The city eventually became a home for factories too. Industrialists made a variety of products, from slide rules to confections. Several famous brands have operated factories in Hoboken, including Lipton Tea, Maxwell Coffee, and Hostess Wonder Bread.

Because of new technology, offshoring, and other factors, Hoboken has lost its heavy industry and shipping, though it still maintains some traces of its rail heritage. NJ Transit has linked much of the state through commuter rail, and seven of its 10 lines start and end at Hoboken's historic Lackawanna Terminal. The terminal also has a major stop on the Port Authority of New York and New Jersey's PATH train line, a 24-hour subway that runs from Newark's Penn Station to the World Trade Center and to 33rd Street in Manhattan. Lackawanna also has a stop on the Hudson Bergen Light Rail, a dock for the New York Waterway Ferry, and stops for several NJ Transit bus lines.

The local economy now supports retail and professional businesses. Besides the City of Hoboken, the two largest employers are the Hoboken University Medical Center and John Wiley & Sons Publishing. Many of the city's professional firms rent space in the Hoboken Business Center in the city's southwest corner and in the Marine View Plaza downtown.

Washington Street is still Hoboken's main commercial street, featuring dine-in and takeout restaurants, bars, clothing boutiques, small offices, and various retail shops. Local rents are currently very high, the national economy is still sluggish, and street parking is competitive and confusing, making it harder for businesses to stay open, but Washington Street is by no means a wasteland. Residents like to joke whenever they see a newly vacant storefront that probably another nail salon will soon move in, but then again, all those nail salons seem to stay in business.

A few businesses had to close after Hurricane Sandy, notably Anastasia's Boutique on Garden Street and some on First Street. But despite the closings and everything else, commerce in Hoboken is still relatively strong. There is great hope the new Pilsener Haus biergarten in a converted factory uptown will become an attraction and bedrock of a redeveloped northwest corner. Pearson Education, a major publisher of textbooks, will relocate its headquarters to Hoboken's waterfront in 2014, bringing upwards of 1,000 new jobs and more hungry workers in town for Hoboken's restaurants.

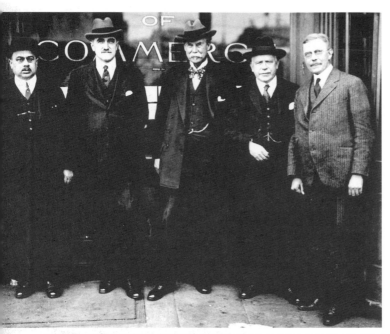

Sweet Tea

Millions of tea drinkers worldwide have enjoyed Lipton tea, which for decades came from the company's Hoboken headquarters. Glasgow-born grocer Thomas Lipton, center, founded the company in 1893 to sell affordable tea to the masses. Just five years later, Queen Victoria knighted him. In 1919, Sir Thomas got a far more prestigious honor, seen here, when the Hoboken Chamber of Commerce welcomed him as a member. (Courtesy of HHM).

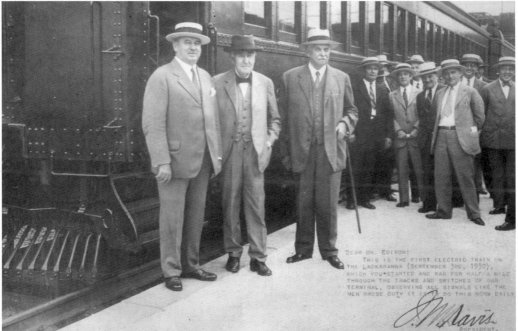

Lackawanna Rail

Hoboken's train station, which is in the National Register of Historic Places, takes one of its names, Lackawanna, from the railroad company that operated out of the station for decades. The Delaware, Lackawanna & Western Railroad ran passengers and goods throughout the region. Its roots dated to the 1830s, and it lasted until merging with a rival in 1960. Here, DL&W president J.M. Davis, left, and chairman William Truesdale, right, visit the company's first electrical passenger train in Hoboken. Joining them is Thomas Edison. (Courtesy of HHM.)

Fisher's Chocolates
Sol Fisher was born in Lithuania and came to the United States at age 13, first to Topeka, Kansas, and eventually to Hoboken. He lent his name to S. Fisher & Co., the candy and chocolate company he ran with his brothers, Asher and Louis, from 1902 until they all retired in 1937. From their factory at Tenth and Clinton Streets, the Fishers made candy bars, breakfast cocoas, and their most popular product, the milk chocolate Pine Apps bar. (Courtesy of HHM.)

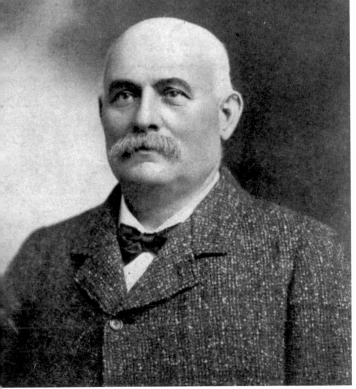

Schmalz and Sons
Hessian-born John Schmalz founded a baking company in Hoboken in 1867 at 527 Park Avenue, and later, he branded it Schmalz & Sons after his five sons. In 1899, the company relocated to a large factory on Seventh and Clinton Streets, where it made its popular Jersey Cream Malt bread. The bakery stayed in the Schmalz family until they sold it in the 1920s to the Continental Baking Corporation, which made Wonder Bread and Hostess cakes. (Courtesy of HHM.)

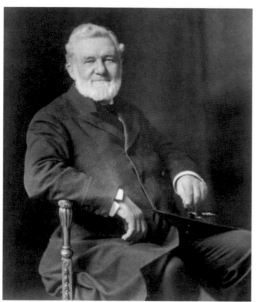

Fletcher Shipbuilding

Scottish brothers William and Andrew Fletcher formed a shipbuilding company with businessman Joseph G. Harrison in 1853. After Harrison left in 1880, the Fletcher brothers renamed the company W. & A. Fletcher and relocated to Hoboken. The company built boilers, engines, and other ship parts. Though William died in 1883, Andrew, seen here, preserved the company and passed it to his son. (Courtesy of HHM).

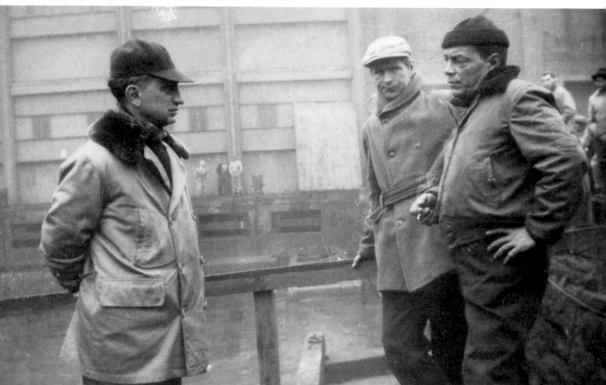

On the Waterfront

In 1949 *New York Sun* investigative reporter Malcolm Johnson won a Pulitzer Prize for his 24-part series of articles about corruption and violence involving longshoremen, union bosses, and mobsters. Five years later, famed Hollywood director Elia Kazan, seen here on the left, adapted Johnson's articles into a feature film, the award-winning *On the Waterfront*, set and shot in Hoboken. (Courtesy of HHM).

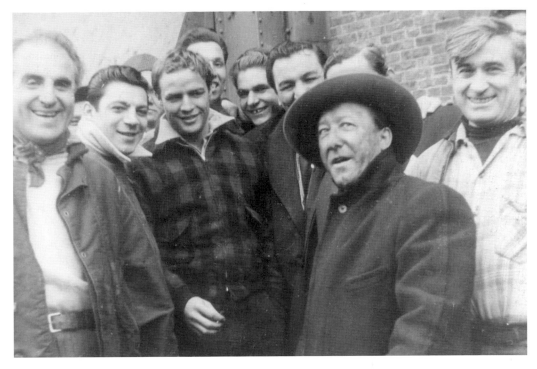

Brando in Hoboken

While filming *On the Waterfront* in Hoboken in late 1953 and early 1954, director Elia Kazan decided to cast actual longshoremen in roles and as extras. Here several surround the film's star, the legendary Marlon Brando, who is third from the left. Besides casting Hobokenites, Kazan also featured many of the city's landmarks, including Church Square Park, Our Lady of Grace Church, and various streets, shops, and piers. (Courtesy of HHM).

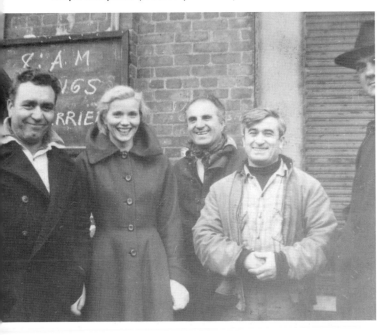

Oscar Approves

Brando won Best Actor and Kazan won Best Director when Hollywood awarded its Oscars in 1954. Karl Malden, just visible on the right, was nominated for best supporting actor. His fellow cast members Lee J. Cobb and Rod Steiger were also nominated. The woman in the photograph, Eva Marie Saint, won the best supporting actress award. Though Saint had appeared on television for years before, *On the Waterfront* was her first movie role. With so much talent involved, including Best Screenplay winner Budd Schulberg, *On the Waterfront* won the Best Picture award and several others in technical categories. (Courtesy of HHM).

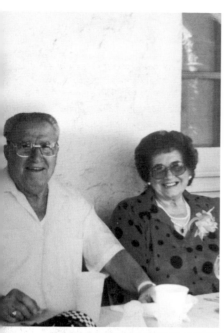

Let's Meet and Eat at Leo's

As young newlyweds in the late 1930s, Leo and Tessie DiTerlizzi began preparing meals in their apartment kitchen and serving them to neighbors. The food was so good that they had to open a real restaurant, Leo's Grandevous—a portmanteau for rendezvous at 200 Grand Street. The husband and wife were friends with Frank Sinatra, who visited often while he still lived in Hoboken. Over the years, Leo and Tessie decorated their restaurant with memorabilia of their famous friend. (Courtesy of Nicholas De Palma.)

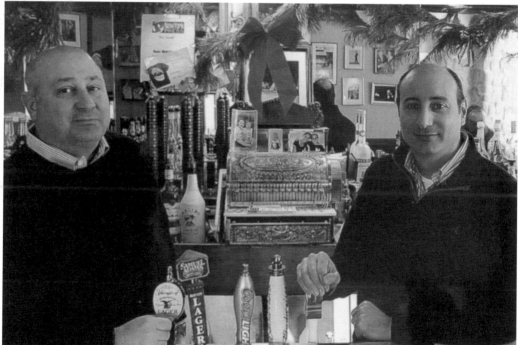

Rendezvous at Grand Today

Nicholas De Palma, right, is the grandson of Leo and Tessie DiTerlizzi. He and his cousin on the left, Sergio De Nichilo, currently own the restaurant. They still serve the same Italian food staples that Tessie cooked decades ago, and they still display the Sinatra memorabilia. In fact, William Bunch, author of the book *Jukebox America: In Search of the Country's Greatest Jukebox*, said that Leo's has the definitive jukebox for hearing Sinatra songs. (Courtesy of Nicholas De Palma.)

Terry on the Street

Though she originally trained to be a dentist, Theresa Castellano has run the City Discount clothing store at 207 Washington Street since 1969. When she's not ringing sales, she enjoys greeting passersby while sitting outside the store with her pet Maltese dog, Ozzie. A third-generation Hobokenite, Castellano comes from one of the city's most prominent families. Her cousin Anthony served as mayor, and she currently serves on the city council with Anthony's son Michael. No councilmember in the city's history, male or female, has served more than Castellano's five consecutive terms. She was also a longtime member of the city's Historic Preservation Commission. (Author's collection.)

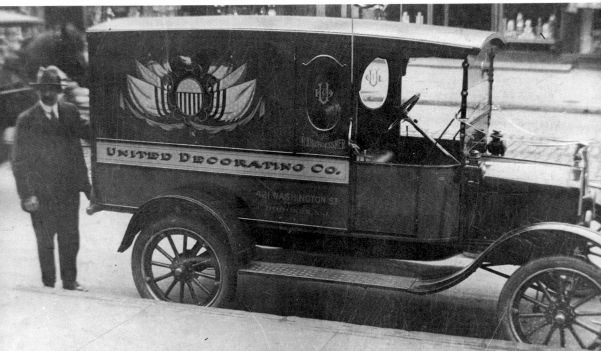

United Decorating

Seen here around 1917 with his company's first truck, Robert Kirchgessner started United Decorating in 1899. Now in the hands of Robert's great-grandson William and his wife, Rose, the business still stands and is seemingly the oldest in Hoboken. From its storefront at 421 Washington Street, United Decorating sells gifts, souvenirs, custom tee-shirts, and Americana. The company has supplied Hoboken with decorations for every celebratory and cultural event through the years, from birthday parties, weddings, and store openings to parades, festivals, and holidays. (Courtesy of HHM.)

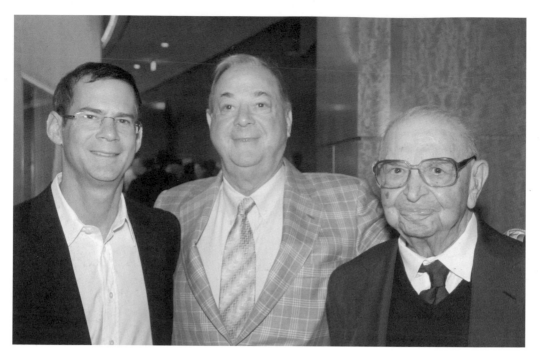

The Barry Boys

It seems everyone in Hoboken has lived in one of the buildings Michael (left), Joe (center), and Walter Barry (right) have built with their real estate development company, Applied Housing. With thousands of tenants, Applied is the biggest private landlord in the city. Walter and his son Joe founded company in 1970, and they have since built dozens of affordable apartment buildings and several luxury complexes, including the Shipyard, 333 River Street, and the W Hotel. Applied also donated the former Bethlehem Steel building to the Hoboken Historical Museum at a lease of $1 per year. (Courtesy of HHM.)

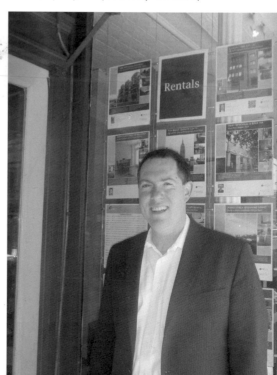

Realtor Dad

After earning a degree in mechanical engineering from Columbia and a master's of business administration in marketing from the University of Michigan, Brian Murray turned to real estate. He has worked in Hudson County for a decade and is now a broker associate with Empire Realty. A father of two, Murray helped found the Hoboken Dads networking group, which organizes cookouts, parties, and holiday events, and also seminars for fathers to learn about saving for college, planning for retirement, and other financial issues. (Author's collection.)

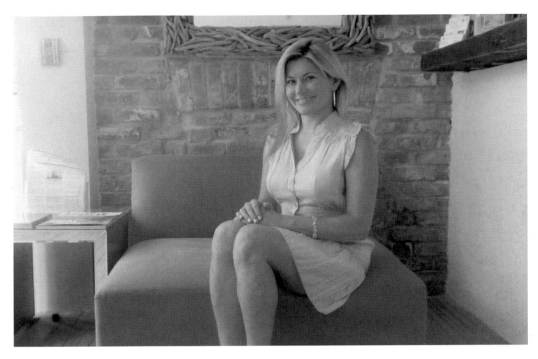

Nicky Nicole

Real estate agents are social people by nature, but few agents can match Nicole Magana's perky spirit. Magana, who works for Boutique Realty, helped a Wall Street executive sell his second home, a luxury condo in Hoboken's Sky Club, and donate the sale to charity. The deal sent over $700,000 to a battered women's shelter. Magana, who once appeared in a *Maxim* "Hometown Hotties" magazine spread, has bartended for the downtown McSwiggan's and spends her spare time attending many of Hoboken's festive social functions. (Author's collection.)

Ronnie Z

Before he turned to selling real estate for Hoboken's RE/MAX office, Ron Zimmerman found success as a professional bowler. Zimmerman is a fourth-generation Hobokenite who graduated from Hoboken High School in 1971. Though his last name is German, Zimmerman's roots are mostly Irish. Some of his past relatives have worked in Hoboken as police officers and on the waterfront. Zimmerman has devoted his spare time to serving the community, for which he was honored as Hoboken Rotarian of the year in 2010. (Author's collection.)

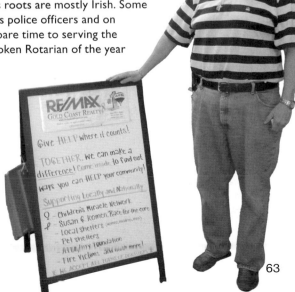

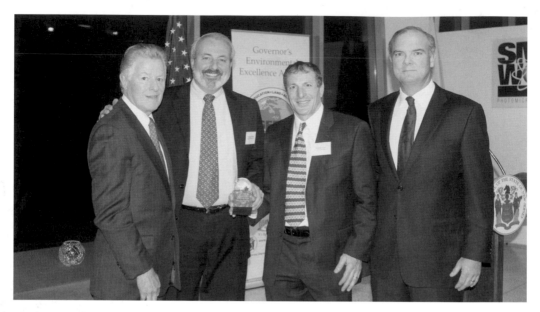

Hoboken Brownstone

Partners George Vallone and Daniel Gans have renovated and designed buildings in Hoboken since 1980. As the founders of the Hoboken Brownstone Company, Vallone, second from the left, and Gans, second from the right, have promoted environmentally conscious development and have won several awards, including this one from the New Jersey Governor's Office. Vallone serves as president of a nonprofit that builds housing for developmentally disabled adults, and Gans has served on the boards of the Hudson School, the Hoboken Historical Museum, and the Mile Square Theatre. (Courtesy of Hoboken Brownstone Company.)

The Gallaghers

The Gallaghers, mom Rehanna and son Padraic, run one of Hoboken's top real estate agencies, Prudential Castle Point Realty. Rehanna started the company in 1995 and annually reaches the top one percent in sales among Hudson County realtors. She has served on various boards and volunteers at the Hoboken YW/MCA. Padraic started as a construction project manager, including for the Crate & Barrel flagship store and baseball star Derek Jeter's residence in the Trump World Tower. He earned his realtor's license in 2009 and is now Prudential's supervising broker. (Courtesy of the Gallagher family.)

Getting the Gang Together

There are several notable men in this 1927 photograph at the Empire Theatre at 118 Hudson Street. The focus is on the man with the mug, a former professional wrestler turned actor named Bull Montana. To Montana's right is Frank Nelson, a former boxer who owned an eponymous restaurant at 109 Hudson Street and later Nelson's Marine Bar & Grill at 300 River Street. Nelson, who grew up in Hoboken, was born Michael Valerio but probably changed his name to avoid boxing promoters' prejudice against Italian fighters. Nelson fought more than 80 bouts during his 12-year professional career and was inducted into the New Jersey Boxing Hall of Fame in 1969. The note on the photograph pointing to the Stack brothers, to the right of Nelson, almost certainly refers to William Stack and Edward Stack, founders of the firm Stack & Stack, which has handled real estate, insurance, and legal business and is still operating at 90 Hudson Street. The significance of Jimmy Carter, marked on the right, is unknown. The dog is possibly a promotional tour stand-in for Rin Tin Tin, a German Shepherd that was popular in movies. Montana had previously acted in a Rin Tin Tin film. The photograph was taken during Prohibition, leading to a question of the contents in Montana's mug. (Courtesy of HHM.)

Blimpie Takes Off

There are more than 1,000 Blimpie submarine sandwich restaurants in the United States and world today, including the first ever, which opened at 110 Washington Street in 1964. Angelo Baldassare, left, Tony Conza, second from left, and Peter DeCarlo, right, were all recent graduates of St. Peter's Preparatory School in Jersey City, and they all had an entrepreneurial spirit. They heard about the long, deli-style sandwiches people were beginning to eat, and they decided to open a restaurant in Hoboken, where they said people like to try new things. They found their name after seeing a picture of a blimp and comparing it to the size of the sandwiches they wanted to serve. (Courtesy of Kahala/Blimpie.)

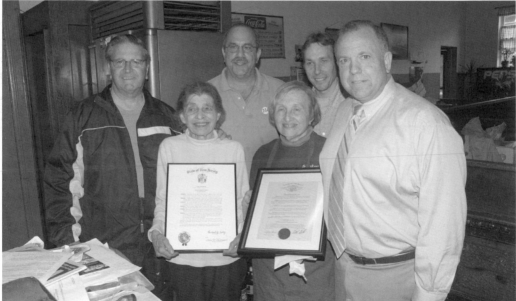

Schnacky's

Schnackenberg's Luncheonette has been an institution in Hoboken since 1931, famous for its grandma's kitchen menu, malt drinks, and classic diner decor. German immigrants Dora and Henry Schnackenberg started the business, and though Henry died in 1950, Dora worked until the early 1990s. Dora and Henry's daughters, Betty Ann, left, and Dorothy, right, started working in the restaurant as children and continued into the 21st century. Betty Ann died in 2008, but Dorothy worked until she retired in 2012. That year, she and her son Mark Novak, second from the right, decided to lease the business to new management that renovated and reopened in 2013. (Courtesy of HHM.)

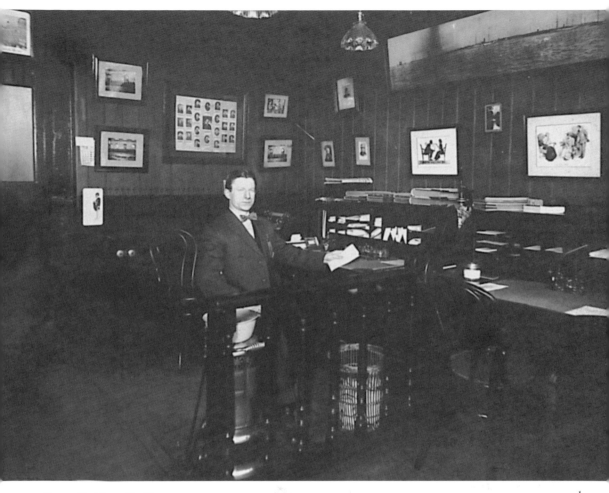

Grandfather Muller

Though he was born in Altona, Germany, John Muller became an American success story with an action-packed biography. Just three years after immigrating, and at only 20 years of age, Muller started Muller Insurance, a company that continues to serve Hoboken into the 21st century. Besides running a thriving business, Muller served as a military police corporal in the US Army during World War I, as a justice of the peace for Hudson County, and as president of the Hoboken Board of Education. He was a member of the Elks Lodge, the Lions Club, the Fraternal Order of Eagles, the Independent Order of Odd Fellows, and many other civic groups. Muller ran a club for the local Democratic Party at Fifth and Bloomfield Streets, moonlighted as a New Jersey state detective, and brokered Broadway shows as a theatrical agent. With his wife, the former Leonore Toepfer, John Muller started a family that has served Hoboken for more than a century and counting. (Courtesy of HHM.)

The Next Mullers

When his father, John, died in 1952, Roger John Muller inherited and expanded the family insurance business. In addition to selling insurance policies, Muller studied law and worked as a real estate agent, serving as president of the Hoboken Board of Realtors in 1959. Like his father, Muller was also a New Jersey state detective. Muller's wife, Hetty, helped run the company's books and is now semiretired. Muller passed away in 2013, but he stayed busy with the business right until the end. (Courtesy of the Muller family.)

The Mullers Today

Siblings Roger Jr. and Erika Muller currently run the insurance business that their grandfather John started in Hoboken in 1906. Like his grandfather and father, Roger is an Elk, and he is also a member of Hoboken's Community Emergency Response Team. Erika is also active in the community and has supported a number of causes. Both Roger and Erika are diehard hockey fans and sponsor and play together on a local adult team, the Hoboken Rockets. The siblings represented their family in 2011 when the City of Hoboken named the intersection of Washington and Tenth Streets near the company office John Muller Way. (Courtesy of the Muller family.)

Board of Trade

Hoboken's business leaders gathered in 1904 to form a city board of trade, an ancestor of the modern chamber of commerce. The businessmen considered several municipal issues affecting commerce, including sewage maintenance, utility access, and the water supply. E.D. Vanderbilt, who co-owned a lumber yard on Fourteenth and Washington Streets, served as the board's first treasurer. (Courtesy of HHM.)

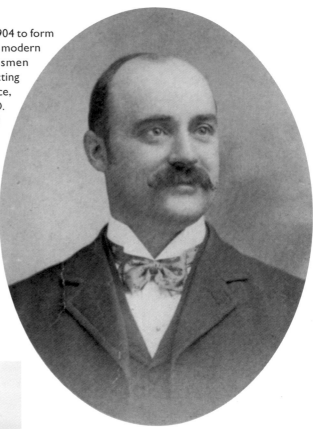

Business Booster

As president of the local chamber of commerce, Greg Dell'Aquila has looked to boost Hoboken's businesses. Dell'Aquila is president of the JDA Group, a real estate company his father, Joseph, a Hoboken native, started during the early 1980s. The younger Dell'Aquila has helped the company build the Lexington luxury apartment building and the Hoboken Business Center. Dell'Aquila is a cofounder of the Mission 50 coworking space, where entrepreneurs share resources, network, and collaborate. He has also served as president of the Hoboken Rotary. (Courtesy of Greg Dell'Aquila.)

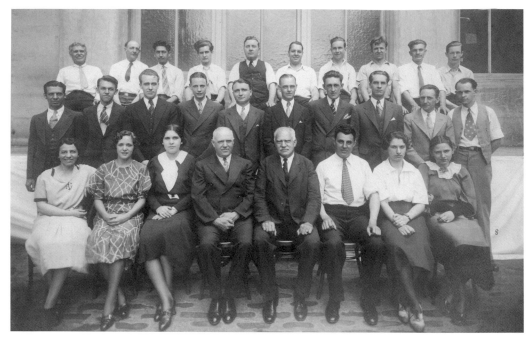

K&E

The Keuffel & Esser company made precision instruments for engineers, architects, surveyors, and other professionals out of its two-building complex on Third Street between Grand, Adams, and Jefferson Streets. Founded by Hoboken residents William Keuffel and Herman Esser in 1867, the company lasted until a 1987 merger. When this employee photograph was taken in 1933, Keuffel's son William, fourth from the left in the front row, was serving as president. (Courtesy of HHM.)

Elegant Walls

With a computer engineering degree from Columbia and a master's of business administration from Dartmouth, Dennis Shah continues Hoboken's industrial history with Studio Printworks, a designer wallpaper company that operates out of a factory on Jackson Street. Shah has served on the New Jersey Economic Development Authority and on the New Jersey Chamber of Commerce Board of Directors. He is an active Rotarian and has donated to several local causes, including helping to build a new teen room inside Hoboken's Boys & Girls Club building. (Courtesy of Dennis Shah.)

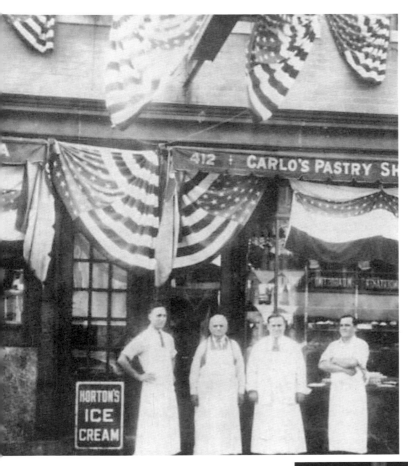

The Original Cake Boss

The bakery brand that Carlo Guastaferro started in 1910 has become Hoboken's most famous since the filming of the television show *Cake Boss*. But decades before the Valastro family bought the business and turned their son Buddy into a star, the Guastaferros were known within Hoboken for treating the city's residents with baked Italian pastries. Carlo, second from the right, emigrated from Italy in 1906 and started the bakery when he was just 18. He later served in the US Army. Here he poses with, from left to right, his brother Charlie, his father, Angelo, and master baker Gabean Napilitino. (Courtesy of HHM.)

The Next Cake Boss

Bartolo Valastro emigrated from the Sicilian island of Lipari and ended up in Hoboken, eventually landing a job as a dishwasher at Carlo's Bakery in the early 1950s. He learned the baking trade from owner Carlo Guastaferro, and he and his wife, Mary, saved enough money to buy the business when Guastaferro retired in 1964. The Valastros kept the name and moved the business from its original location at 412 Adams Street to its current one at 95 Washington Street in 1989. When Bartolo died in 1994, Mary ran the business before she retired in 2010 and passed it to the children she and Bartolo raised. (Courtesy of Carlo's City Hall Bake Shop.)

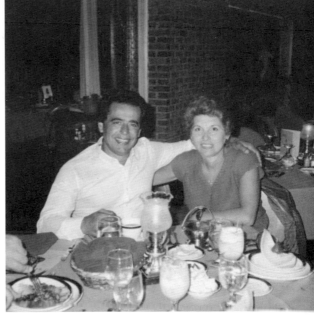

The Cake Boss Today

Buddy Valastro had been dazzling customers with his elaborate cakes when the TLC network began filming him for the reality television show *Cake Boss*. Valastro has parlayed the successful show into an empire spanning public appearances, two spinoff shows, cookbooks, a large factory, and satellite locations. *Cake Boss* is still airing new episodes, and its bakery draws thousands of tourists to Hoboken every year. Valastro and his family have honored their Hoboken roots by donating money, time, and, of course, baked goods to a number of local causes. (Courtesy of Carlo's City Hall Bake Shop.)

The Boss's Sisters

Though Buddy Valastro gets to be the boss, he could not run the Carlo's empire without his four sisters: from left to right, Lisa, Grace, Maddalena, and Mary. The sisters have serviced customers at the bakery's front counter, run the company's books, and become visible personalities on *Cake Boss*. Maddalena's husband, Mauro, and Grace's husband, Joe, work with Buddy in the company's new bakery factory in Jersey City. (Courtesy of Carlo's City Hall Bake Shop.)

King of the Heel

Shoemaker Giovanni Perrupato's life has been an odyssey. He was born in Havana to Italian parents, who sent him to live in Italy when he was eight years old. His family moved to America in 1960 and opened a shoe-repair shop on the corner of Seventh and Garden Streets. Perrupato joined them that year and has been working in the business ever since, fixing many boots, loafers, and trendy pairs of high heels. The city honored him by naming the intersection Cobbler's Corner, though Perrupato has since taken one more journey, moving the business in 2012 to a larger space on Willow Avenue. (Courtesy of the Perrupato family.)

Mr. Chocolate

Mario Lepore continues Hoboken's heritage as a sweets-making city with Lepore's Home Made Chocolates at 105 Fourth Street. Since 1980, Lepore and his family have treated Hobokenites with delicious chocolates, whether in mixed boxes for individuals or large platters for parties. Lepore's is especially popular during the winter holiday season, and it has helped many Hoboken men woo their sweethearts on Valentine's Day. When he's not making chocolate, Mario Lepore is one of Hoboken's resident Sinatra experts. For a time, he operated a small museum near the singer's birthplace, and he still displays Sinatra memorabilia in his shop. (Author's collection.)

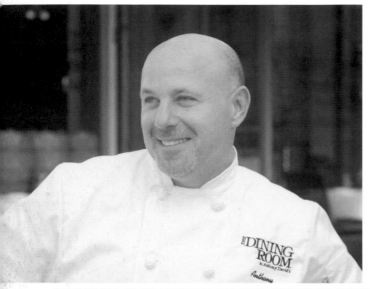

Chef Pino

Hobokenites can find fine dining at the two restaurants chef Anthony Pino owns: the intimate Anthony David's and the wine bar Bin 14. Both offer romantic settings and frequently serve couples on dates, especially for brunch. Hobokenites can also buy gourmet goods to take home from Anthony David's adjoining café. Pino also caters events throughout the region with his AD Catering & Events Company, and with the owners of the Pilsener Haus biergarten, he co-opened the Kolo Klub, a 1920s, Eastern European–themed event hall and cocktail lounge that hosts weddings, benefits, and other parties. (Courtesy of Anthony Pino.)

Lovely Rita, Data Maid

Rita Gurevich graduated from Stevens Institute of Technology with degrees in computer science and mathematics, worked in finance for a few years, and then returned to Hoboken to launch SPHERE Technology Solutions, a data management company. *New Jersey Monthly* magazine named her one of the Top 25 Leading Women Entrepreneurs in the state. Besides managing data for corporate clients, Gurevich and SPHERE contribute to the Hoboken Adopt-a-Soldier program. (Author's collection.)

Hobarking

Hoboken is full of pets, especially dogs of all sizes. Since 2003, husband and wife Laura Wrazel and Karl Gerstner have served Hoboken's pet owners with their store, Beowoof Provisions for Pets at 106 Fifth Street. Wrazel and Gerstner sell food, beds, crates, toys, grooming supplies, accessories, and other products, and they also sponsor regular pet-adoption drives. The two enjoy an annual tradition of taking a holiday photograph in their store with their dogs Zoe, the store's chief of security, and Lola, an expert bed demonstrator. (Courtesy of Laura Wrazel and Karl Gerstner.)

In a Tight Knit Town

Jersey native Patricia Scribner moved to Hoboken at age 23 to be closer to her job, but just four years later, she left finance to pursue her dream of owning a knitting store, a dream she had since learning how to knit from her mother as a child. She has owned Patricia's Yarns since 2004, where she sells yarn and other accessories for knitting, crocheting, and other skills. She also hosts several popular classes where women (and some men too) come to knit, sit, and chat. Scribner lives with her family in Hoboken and contributes to the Hoboken Shelter and other causes. (Author's collection.)

Finally, A WindMill in Town

Hoboken native Roger Corrado, right, worked on Wall Street for 25 years and reached the rank of vice chairman of the New York Board of Traders. Then in 2011, he retired to pursue his dream. Corrado had been a fan of the popular and Zagat-rated Jersey Shore hot dog chain WindMill since he started vacationing in Belmar as a child. He opened one in his hometown with his business partner, a fellow Wall Streeter named Tim Cochrane, on the left. Their grand opening party welcomed Corrado's actor brother Alex, actor Danny Aiello, and comedian Artie Lange. A tough business climate forced the downtown restaurant to close at the end of 2013, but while it was open it featured a large Hoboken-themed mural of Frank Sinatra, Carlo's Bakery, and New York Giants quarterback Eli Manning. (Courtesy of Roger Corrado.)

CHAPTER FOUR

Hoboken in Motion

Hoboken residents keep a calendar that is full of annual cultural events. Every year, the city sponsors parades for Memorial Day and Halloween, spring and fall art and music festivals, Christmas tree and Hanukkah menorah lightings, and a new green fair, among many other events. Civic groups sponsor community service days, fundraisers, races, food-tastings, happy hours, bar crawls, and other gatherings. In Hoboken, there seems to be something interesting happening every day.

Hoboken has a visible and vibrant religious community. Many of the current houses of worship date to the 19th century. Hoboken's clergy have helped open the city's homeless shelter, started schools, and comforted the city in difficult times, such as during the 9/11 terrorist attack that killed 57 Hoboken residents. Newer religious groups such as Hoboken Grace Church have encouraged congregants to volunteer within the city.

For a time, after the heavy industry left but before gentrification, Hoboken became a haven for artists. Many painters, sculptors, musicians, and writers could afford to live and work in the city. Many have since left due to rising rents, but a few still remain, working out of retrofitted factories such as the former Neumann Leather building. Groups such as hob'art and galleries such as the Barsky Gallery have organized Hoboken's artists and showcased their work.

Many people in Hoboken involve themselves in the city's pastime, local politics. It is a full-contact sport that has inflamed passions, incited feuds, and led to more than a few people getting into legal trouble. Local politicians curry favor by trying to be a best friend to constituents. Supporters wear campaign tee-shirts, canvass streets, and distribute literature for their favorites. Residents debate the issues, sometimes respectfully but sometimes not, on local news sites and blogs.

A large percentage of Hoboken's residents are educated professionals in their 20s and 30s who work to help their community through a number of civic groups, including TRUE Mentors, Hoboken Volunteers, and Party With Purpose. These young altruists donate money and time to make Hoboken a better place to live.

Reverend Geoff

Rev. Geoff Curtiss began ministering to the congregation of All Saints Episcopal Church in the early 1980s. Since that time, Curtiss has left three indelible testaments to his legacy of service. In 1982, Curtiss and other local clergy opened the Hoboken Homeless Shelter after the city government and real estate developers, eager for gentrification, outlawed boardinghouses, pushing hundreds of low-income residents onto the streets. Curtiss risked imprisonment when the city claimed that the shelter violated zoning laws, but a judge overruled the city, and the shelter has stayed open ever since. Later, Curtiss helped All Saints open the K-8 All Saints Episcopal Day School, and he also helped found the Jubilee Center, an after-school program and "safe haven" for children in public housing. Curtiss, seen here with his wife, Linda, retired from All Saints at the end of 2013. (Author's collection.)

Rabbi Rob
Robert Scheinberg has led much of Hoboken's Jewish community since 1997 as rabbi of the United Synagogue of Hoboken. Scheinberg has built religious and cultural bridges throughout the city by collaborating with the clergy of other faiths. He has given prominent voice in times of sorrow, such as after the 9/11 attack and during the city's annual remembrance ceremony, and in happier showings of heritage and celebration. Outside of Hoboken, Scheinberg served on the New Jersey Legislature's Death Penalty Study Commission, whose report led to the state abolishing capital punishment in 2007. (Author's collection.)

Father Bob
Robert Meyer's professional career would make for a very interesting evening television drama. He is both a monsignor at SS Peter & Paul Church and a practicing attorney. He graduated from Seton Hall law school in 2000 and now teaches there as a professor. He also serves as counsel to a mid-sized firm. Meyer was ordained as a priest in 1988. Prior to coming to SS Peter & Paul, he served as chief of staff to the president and chief executive officer of St. Vincent's Catholic Medical Center in New York. Meyer, who was born in Hoboken, came to SS Peter & Paul in 2010 and has led its community and social justice efforts, including volunteering at the Hoboken Shelter, combating food insecurity, and advocating against human trafficking. (Author's collection.)

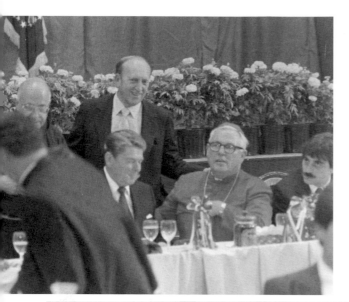

The St. Ann's Festival

Perhaps no cultural event in Hoboken is as grand as the summer St. Ann's festival, a five-day street fair filled with carnival games, food vendors, a beer garden, live music, and other attractions. Most Hobokenites plan to attend at least one night, and thousands of people come from outside Hoboken to attend, with almost everyone looking to enjoy some of the festival's famous fried Zeppole pastries. Sometimes even famous people show up, such as Pres. Ronald Reagan, who visited while campaigning for reelection in 1984. (Courtesy of HHM.)

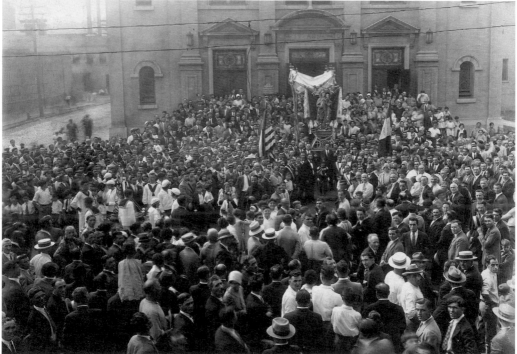

To See the Saint

The Church of St. Ann on the corner of Seventh and Jefferson Streets has been hosting its festival every year since 1910. Now under the leadership of parishioners Mario Ferrara and Marie Tataro, the originally modest affair for a congregation of modest Catholic immigrants has grown into a big regional draw. During the festival week, the church holds a special service and presents a large statue of Saint Ann. The more punctual worshippers arrive early enough to find a seat inside, and several hundred others wait outside on what is usually a very hot weekday to see the ornate and serene statue. The statue has proven to be a timeless attraction. This photograph taken around 1930 could just as easily show the scene today. (Courtesy of HHM.)

The Saint Comes Marching In

Ann is the patron saint of pregnant women. Since many women believe she has carried them through difficult times, they are willing to carry her 600-pound statue out of the church and in a procession throughout the city. Carrying the statue has been a rite of passage for many Hoboken women, and many have walked in bare feet as a show of sacrifice. (Courtesy of HHM.)

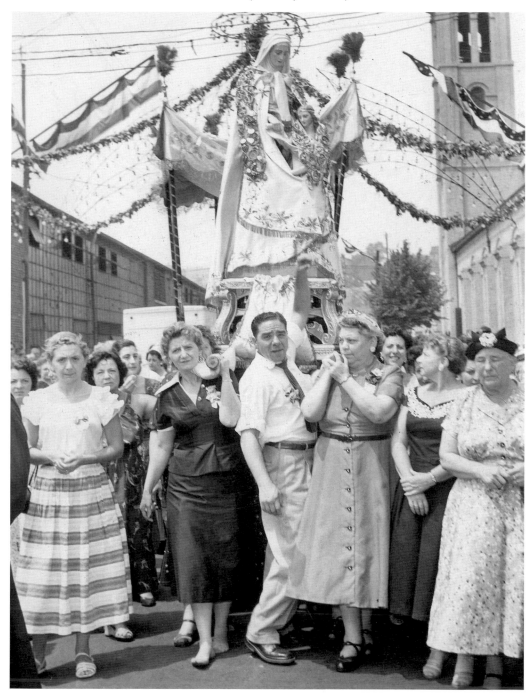

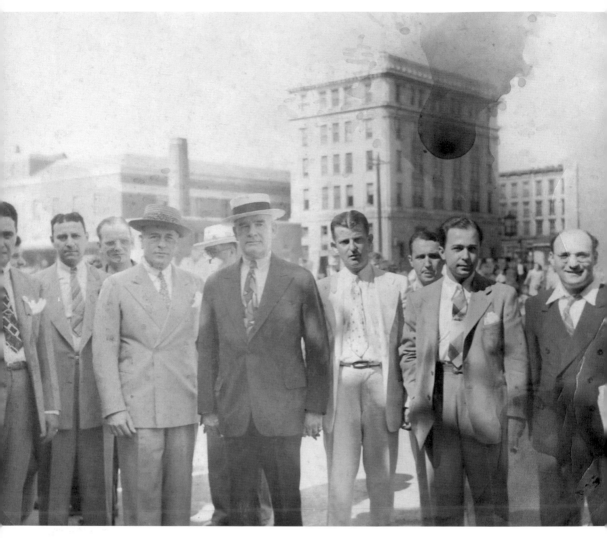

The Hoboken for Hoboken's Hobokenites Association

Many Hoboken politicians start civic organizations to attract and rally supporters. These groups often host neighborhood events such as block parties to meet constituents. Fred DeSapio took the people in this photograph and many others on a boat excursion as part of his DeSapio Democratic Association. DeSapio, in a hat, is to the left of Mayor Bernard McFeely, the man in the center wearing the dark suit. When voters ended McFeely's 17-year reign but failed to settle on a replacement, the city council gave the job to DeSapio, who served as mayor from 1947 to 1953. Though DeSapio billed himself as a reformer, police later raided his clubhouse and arrested five men for gambling, including DeSapio's secretary. (Courtesy of HHM.)

The Campaign Soldier

Hoboken may have given the world baseball, but its own pastime is fighting over local politics. The city has annual school board elections, mayoral elections every four years, and city council and state legislative elections every two years, with various primaries, runoffs, and party committee elections every cycle. Though this particular man is anonymous, he represents the hundreds of campaign soldiers who work to register voters, obtain petition signatures, canvass residential blocks, hold signs, distribute campaign flyers, write blogs, and shout down the opposition. Most of these campaign soldiers, whether they're among the city's poorest or richest residents, will wear color-coordinated campaign shirts on Election Day and pressure their neighbors with slogans such as "Vote Column A all the way." (Courtesy of HHM.)

Mayor Cappiello

Only Bernard McFeely has surpassed Steve Cappiello's 12-year tenure as Hoboken mayor. Seen here on the right talking to New York mayor Ed Koch, Cappiello was a former police sergeant who was first elected to the city council in 1963. He then won three terms as mayor from 1973 to 1985, defeating incumbent Louis De Pascale by 84 votes. Cappiello also served as a Hudson County freeholder from 1981 to 1984. During his time in office, Cappiello pushed for an urban revitalization that has continued to shape Hoboken in the present day. He helped found the Hoboken Boys & Girls Club and was a member of the Veterans of Foreign Wars, the American Legion, the Hoboken Elks, and the Hoboken Knights of Columbus. After leaving office, Cappiello, who died in 2013 at the age of 89, was still an elder statesman whose endorsement other Hoboken politicians wished to attract. (Courtesy of HHM.)

Mayor Vezzetti

It was something of an upset when Tom Vezzetti, who claimed to be the son of a bootlegger, defeated longtime incumbent Mayor Steve Cappiello during the city's 1985 municipal election. Vezzetti won by barely 300 votes out of more than 13,000 cast. Vezzetti would only serve three years before dying in office in 1988, but his tenure left a memorable impression on Hoboken and onlookers outside. (Courtesy of HHM.)

Tom Vezzetti used to walk the streets with a bullhorn criticizing politicians, now he's the mayor. A former tavern owner with a Masters in "Histrionics" from NYU, he admits to sleeping more than one night on a pool table. His political career began in earnest when he picked up 32 odd sport coats at Schlesinger's of West New York's going out of business sale.

When Georgie Hull isn't pumping gas across from The Citadel, "Hoboken's most prestigious address" (formerly known as P.S. 8), he's fishing for bass and eels from the piers. Does he eat what he catches? "No way, I may be nuts, but I'm not crazy." (facing page)

Theatrical Tommy
Tom Vezzetti launched his first bullhorn campaign in 1982, when he began marching up and down Washington Street to announce he would challenge the sitting city council president. Vezzetti won that election and employed the bullhorn again when he ran for mayor in 1985. During the campaign, Cappiello questioned Vezzetti's competence, but the upstart forced the veteran into a runoff and then defeated him one on one. (Courtesy of HHM.)

The People's Mayor
The *New York Daily News* dubbed Hoboken mayor Tom Vezzetti the "Wackiest Mayor in America." It was a distinction Vezzetti earned for reasons beyond wearing loud clothing as he is here during Hoboken's annual Halloween parade. He would sometimes wear mismatched shoes, would often go unshaven, and would carry his belongings in paper bags. He was recognizable enough outside of Hoboken that even the *Los Angeles Times* wrote an obituary about him. But besides his eccentricity, Vezzetti was a passionate populist who wanted to guard Hoboken's most vulnerable residents from the rapid upheaval of gentrification. His spirit lives in every battle Hoboken's current residents fight over development. (Courtesy of HHM.)

Gimme Shelter

Hoboken has had a tragic history of homelessness, one that peaked when city redevelopment policies in the late 1970s outlawed low-income boardinghouses, sending many poor and older residents onto the streets. Many other people have found themselves there during hard economic times. But the local clergy joined together to open the Hoboken Shelter in 1982, and since then, the shelter's staff, including executive director Jaclyn Cherubini, right, and board of directors member Dinorah Vargas, left, have worked to provide warm beds and hot meals to people in need. Just recently, the shelter served its two millionth meal. The shelter gives even more by helping its guests find jobs and permanent housing. Even in bad economic years, the shelter manages to help as many as 150 people regain self-sufficiency. (Courtesy of the Hoboken Shelter.)

The Best Books (and More) in Town

The employees who work at the Hoboken Public Library run the third-oldest library organization in New Jersey, dating to 1884, and they maintain the oldest library building in the state, dating to 1897. Thanks to its dedicated and innovative staff, the library has evolved with the times. It still has books, but it also offers classes and workshops, hosts community meetings, screens films, and now loans modern technology such as e-readers and tablets. Lina Podles, second from the left, has served as the library's executive director since 2001. Surrounding her are reference librarian Matt Latham, teen librarian Ona Gritz (in striped pants), and public relations director Laura Knittel (wearing the scarf). The librarians have recently embarked on a massive renovation of the building, with plans to add modern amenities to its classic architecture. (Author's collection.)

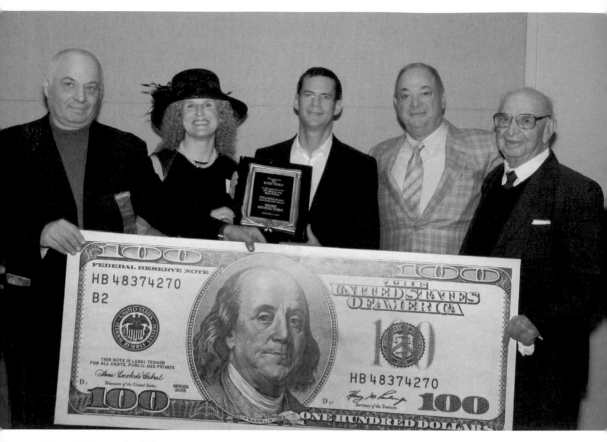

Meet Me at the Museum

It's fitting that a city with so much history should have a busy museum that seeks to capture Hoboken's past. The Hoboken Historical Museum formed in 1986, but it didn't have a permanent home until 2001. That's when the Barry family, owners of real estate development firm Applied Housing, offered the museum's trustees a 100-year lease at $1 per year in the former Bethlehem Steel machine shop at 1301 Hudson Street. The museum, led by executive director Bob Foster, left, and trustee member Carol Losos, ceremoniously paid the bill during the museum's 25th anniversary gala in 2011. The museum can now focus on telling the story of Hoboken. It stays open six days a week throughout the year. The museum has held major exhibits on Hoboken's industrial, shipping, and confectionary history, Hoboken's social groups, the nearby Holland and Lincoln Tunnels, and many other topics. It hosts lectures throughout the year in its main floor and usually features an art exhibit on the upstairs level. The museum also supports the Hoboken Fire Department Museum at 213 Bloomfield Street, a story-time series for children, an oral chapbook series, the city's pet and baby parades, house and garden tours, and an annual family fun day. (Courtesy of HHM.)

Trailblazers for Fighting Blazes
In 2002, Maria "Peggy" Diaz, left, and Audra Carter, right, became the first female firefighters in Hoboken and Hudson County. Carter had transitioned from bartending, and Diaz first realized she wanted to become a firefighter while serving in the Navy. Besides passing rigorous training and meeting demanding physical standards, Diaz and Carter became trailblazers for all the female firefighters in the county who have and will follow them. They were both promoted to the rank of captain in 2011 and have helped the Hoboken Fire Department maintain its Class 1 rating from the Insurance Service Organization, a distinction only two dozen departments nationwide can claim. (Author's collection.)

Officer Colon
Police officer Elias "Leo" Colon never thought he'd get on national television just for doing his job, but that's what happened when he accompanied Mayor Dawn Zimmer during her survey of the city immediately after Hurricane Sandy. Colon, a former Marine and 10-year veteran of the Hoboken Police Department, was riding in a payloader truck with the mayor and a CNN reporter when he spotted a woman trapped in her car and surrounded by several feet of water. "I heard a woman screaming for help, and I thought that must be someone's mother," Colon remembered. "I went in the water, got her out of the car, put her on my back and put her on the truck." Colon later rescued two men in a similar predicament, as the CNN camera rolled. The network later aired the footage during a segment with host Anderson Cooper. Colon said he did not hesitate to rescue the residents, even though there could have been dangerous downed power lines lurking in the water. "That's my job," he said. "I would do it again." (Author's collection.)

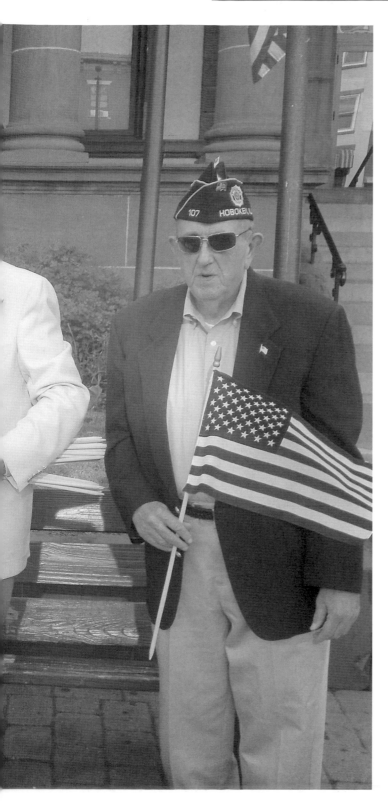

Answering the Call to Serve

At least 71 Hoboken residents died serving during World War I, 158 died during World War II, 3 died in Korea, and 9 died in Vietnam. It is in their memory that Hoboken's surviving veterans gather every year for the city's Memorial Day parade, the oldest in the state of New Jersey. Here, from left to right, are 1960s Army veteran Jimmy Farina; Navy veteran Dennis Favuzzi, who served from the 1970s to the 1990s; Vince Wassman, who served in the Navy during World War II and in the Army during the Korean War; American Legion Post 107 president and former Marine Tom Kennedy; and Vietnam War Army veteran Bob Carroll. Kennedy, a former police officer and city council member, died five weeks after posing for this photograph. (Author's collection.)

Spirit of '76

Jack O'Brien, front row left, has marched along Washington Street in 70 of Hoboken's first 115 Memorial Day parades. A veteran of the Merchant Marines during World War II, O'Brien said he doesn't worry about the walk despite his advanced age. "It's only a mile," he said casually before the 2013 parade. O'Brien, who learned music from Julius Durstewitz, plays the fife with his band, including Barbara Dabinett and Dom DeVito in the front and O'Brien's son Brian O'Brien and granddaughter Amanda O'Brien. (Author's collection.)

The Women of St. Mary

In 1966, several civic-minded women formed the St. Mary Hospital Woman's Auxiliary in conjunction with Hoboken's only hospital. A for-profit company bought the financially strapped hospital, now known as Hoboken University Medical Center, in 2011, which led to the auxiliary group changing its name and affiliation due to a state law that prohibits for-profit hospitals from accepting gifts from nonprofit groups. Now knows as the St. Mary Advocates, the group supports community health initiatives and has given money for nursing scholarships, wounded veterans, autism awareness, the Hoboken Volunteer Ambulance Corps, and other causes. It has given over $2.7 million combined. Here, four of the current advocates, from left to right, Gwen Shook, Cookie Raggio, Lucille Casulli, and Maria Reilly, stand in front of the group's thrift store on the corner of Sixth and Garden Streets. (Courtesy of the St. Mary Advocates.)

One, Two, Three, Jubilee

Every time children at the Jubilee Center pose for a photograph, they say cheese by shouting, "One, two, three, jubilee!" The Jubilee Center is an after-school program and safe haven for under-served children in Hoboken's public housing project. The program started through the All Saints Community Service and Development Corporation in 1996 and moved to a 9,000-square-foot building on Sixth and Jackson Streets in 2003. Led by executive director Armstead Johnson, left, and program director Craig Mainor, right, the Jubilee Center offers children homework help, positive reinforcement, athletics, an art and music program with opportunities to perform in public, field trips to museums, zoos, and other stimulating places, and a summer camp. It also helps teenagers prepare for the adult world by sparking a career interest and helping them apply for college. (Author's collection.)

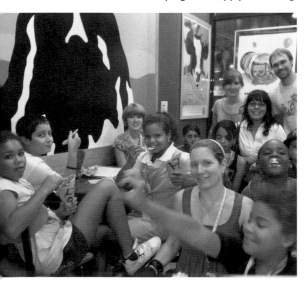

TRUE Susi

In 2010, Susi Tully Milligan, in the lower right corner, helped found TRUE Mentors, Hoboken's only one-to-one mentoring program, with her church, Hoboken Grace. The program has grown quickly, pairing children ages 6 to 17 with young adult mentors who help the children deal with the tribulations of growing up, motivate them for school, and spend time doing positive activities. TRUE Mentors also offers classes and group activities for all the mentor and mentee pairs to meet, learn, and socialize. This photograph shows one class inside Hoboken's Ben & Jerry's, where the children and their mentors learned how to make ice cream. In 2013, Milligan shifted to serve as president of the TRUE Mentors board of directors, opening the door for new executive director James Sproule. (Courtesy of Susi Tully Milligan.)

Greetings From Hoboken

A self-taught painter, illustrator, and graphic designer, Raymond Smith depicts Hoboken's architectural beauty with his Greetings from Hoboken artwork, a colorful rendering of the city's waterfront and notable buildings. Smith reproduces the image on shirts, coffee mugs, and other products. He has exhibited his work at the Hoboken Museum and other local galleries. In 2002, Smith created the Hoboken Children's Memorial Flag to honor the Hobokenites who died on 9/11. The flag, a five-by-nine-foot acrylic-on-canvas painting, features the handprints of children related to the victims. It was the first public memorial representing Hoboken and is on permanent display in the Hoboken Board of Education building. "It's not the sort of art that I usually make, but it's become one of the things I am most proud of," Smith has said. (Courtesy of Raymond Smith.)

Hoboken Art

Several of Hoboken's most established artists met in 2002 to form hob'art, a cooperative gallery where members work together to support the art community. After hosting exhibits in various spaces throughout the city, the group opened its own permanent space inside the Monroe Center for the Arts in 2012. The group hosts several exhibits during the year, featuring painters, sculptors, mixed-media designers, and experimental artists. This photograph shows, from left to right, the group's president Elizabeth Cohen, its public relations director Roslyn Rose, and its gallery director France Garrido, who are all working artists, as they celebrate the opening of the new permanent home. (Courtesy of hob'art.)

Barsky Art

Albert Barsky is an eminent presence in Hoboken's artistic community thanks to his leadership and promotional skills. Since 2011, his contemporary gallery in a converted factory at 49 Harrison Street has connected collectors, enthusiasts, and people discovering art to a litany of talented but largely unseen local and even international artists. The gallery sells and rents eclectic, museum-worthy paintings and sculptures, arranges new commission work, and designs artistic spreads for residences and corporate clients. In 2012, Barsky helped organize the Hoboken Gallery Walk, a popular monthly self-guided tour for people to explore the city's art scene. (Courtesy of Albert Barsky.)

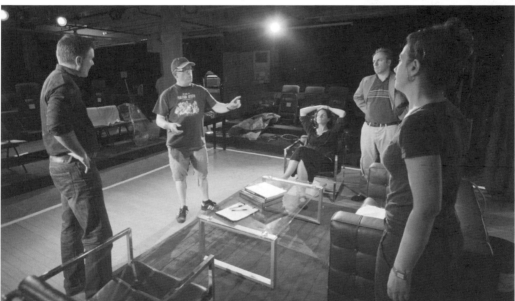

The Show Must Go On

Longtime theatrical director Chris O'Connor had been living in Hoboken when he realized the city could use a professional theater company. He helped found the Mile Square Theatre and continues to serve as its artistic director. The company's annual season includes a spring musical, a fall drama, and a December radio play rendition of *It's a Wonderful Life*. The company also honors Hoboken's baseball history with an annual production, *The Seventh Inning Stretch*, which features seven original 10-minute plays about baseball. Here, O'Connor, wearing a hat, directs actors, from left to right, Charlie Kevin, Annie McAdams (O'Connor's wife), the company's associate artistic director Matthew Lawler, and Patricia Buckley in 2011's *God of Carnage*. (Courtesy of Mile Square Theatre; photograph by Craig Wallace Dale.)

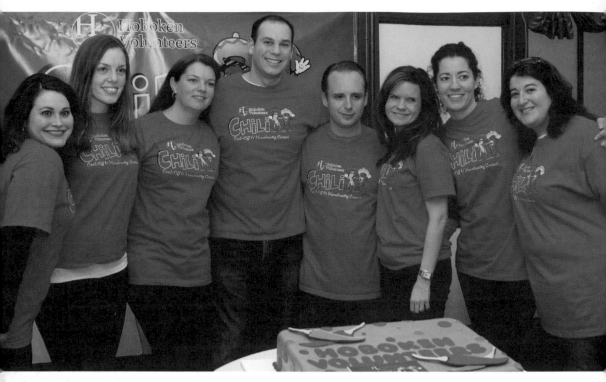

Hoboken Volunteers

One of the first things Tim Occhipinti, fourth from the left, did upon moving to Hoboken in 2009 was to help found the Hoboken Volunteers, a group that raises money for local causes and looks for opportunities to serve the community. The group has led neighborhood cleanup efforts and taken children on field trips, among other projects. The group's most popular fundraising event is its annual chili cook-off, which draws several hundred people and dozens of competition entries every February. With Occhipinti are, from left to right, fellow Hoboken Volunteers Angela Cornelius, Erin Muller, Jeanine Crysler, Ed Wentzheimer, Taryn Crosby, Sera Coughlin, and Julie Oshinsky Mintz. (Courtesy of Hoboken Volunteers; photograph by Studio 21 Productions.)

Party With Purpose

In the months following the 9/11 terrorist attack, Hoboken resident Scott Delea, front center, felt compelled to get involved in his community. He founded Party With Purpose, a nonprofit with a motto of "Work Hard, Play Hard, Give Hard." The group has two signature events: an annual winter fundraiser party and a 5k race along the Hoboken waterfront that challenges over 1,000 runners every summer. The events have helped Party With Purpose donate almost a half million dollars to local charities and other causes beyond Hoboken since 2002. The group also sponsors a large holiday toy drive for the local Boys & Girls Club. This photograph during the winter benefit features Party With Purpose board members including, from left to right, (first row) Ryan Mitchell, Stacey Warren, Jackie Lebowitz, Scott Delea, Lisa Harap, Joann Costanzo, and Colleen Cingel; (second row) John Mollard, Lisa Conover, Kate Linarducci, Melissa Gitliz, Jennifer Finnerty, Alisha Cipollone, Mizanne Francis, Derek Pines, Jenifer Nastasi, Al Miesemer, Jillian Dodge, Anja DeRosa, and Brian Reighn. (Courtesy of Party With Purpose; photograph by Brokaw Photography.)

Service Above Self

The Hoboken chapter of Rotary International formed in 1921. The chapter's members include lawyers, accountants, shopkeepers, and business owners. The group holds its weekly lunch meetings every Tuesday at noon at the downtown Biggie's. The chapter's commitment to the Rotary's motto of "Service above self" includes giving dictionaries to third-graders and then challenging them the following year in a citywide spelling bee for fourth graders; awarding $5,000 college scholarships to three to five high school students every year; and raising money after disasters, such as Hurricane Sandy or the fire that destroyed 300 Washington Street. These three Rotarians—financial planner Chris Mackin, left, Dr. Kathia Roberts-Moore, and firefighter captain Rich Marsh—have been some of the Hoboken Rotary's most prominent leaders. Mackin and Marsh have each recently served as club president. (Author's collection.)

CHAPTER FIVE

The Mile Square

Hoboken has seen a lot of changes during its history. It has gone from tribal hunting ground to colonial outpost to pastoral playground to immigrant magnet to transportation hub to industrial hive to abandoned hellhole to artist haven to revitalized hotspot. Baseball isn't really the national pastime anymore, and Frank Sinatra's star fades a bit more every year, but then again people have a new interest in a 100-year-old bakery, and they're still meeting and eating at Leo's.

And what is Hoboken now? It's a mix. It is home to well-educated professionals who make large salaries working in Manhattan. It is home to growing families with parents who want to give their young children the excitement of city life. It is home to twentysomethings fresh out of college who enjoy the city's wild bar scene. It is still home to longtime residents—the proud "Born & Raised"—plus a few leftover artists and others famous outside of the city limits. Hoboken is enough of a mix to where no one group can get everything it wants.

Hoboken is a city in transition. Its residents will continue to debate its direction. They will continue to argue over taxes and the budget, the school board, the scale of development, creating open space, the scourge of corruption, flooding during rain, and disaster during hurricanes, how to boost commerce, how to mitigate rowdy bars, and perhaps most importantly, how to find a parking spot within 10 blocks in less than 20 minutes.

Whatever the issue is, people in the city care. Everyone has an opinion on something. Here are a few of the notable residents who will shape those debates, these modern legendary locals of Hoboken.

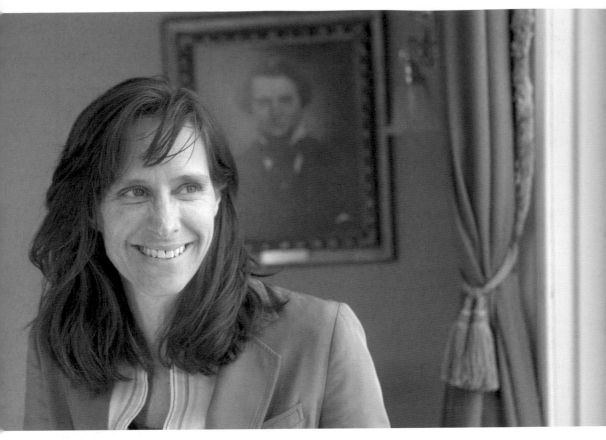

Meet the Mayor

Just a few years ago, Dawn Zimmer went to a community meeting in her adopted home of Hoboken to urge the city to block a high-rise that would clash with the neighborhood's low-rise skyline and to build instead a park in the city's southwest corner. That first meeting started her civic career; soon after, she was elected to the Hoboken City Council and then as mayor in 2009. As mayor, Zimmer has focused on balancing residential and commercial development and cultivating open space projects. She has presided over the opening of Pier C Park on the waterfront and 1600 Park uptown, and she has steered the long process for getting land and funding to build that southwest park. Zimmer has also promoted fiscal responsibility by calling for lower taxes, a leaner budget, and a reserve fund for emergencies. She pushed for the sale of Hoboken University Medical Center, a hospital the city saved from bankruptcy, back to a private firm, freeing the city from a $52-million bond commitment. Zimmer's administration has also introduced bicycle, digital parking meters, a car sharing program, a local bus fleet, flood sensors, an annual state of the city address, citywide shopping promotions, and various other infrastructure, cultural, and quality of life improvements. She became recognizable to many people throughout the United States after Hurricane Sandy flooded Hoboken. She gave national television interviews to raise awareness of the situation and plead for help. While riding in a payload truck with a CNN reporter, Zimmer helped police officer Leo Colon rescue a woman who had gotten stuck while trying to drive in several feet of water. Zimmer, who was the first woman to serve as mayor of Hoboken, lives with her husband and two sons. She was reelected in 2013. (Courtesy of the City of Hoboken.)

The Assemblyman

Ruben Ramos Jr. represented Hoboken and the 33rd legislative district in the New Jersey State Assembly from 2010 to 2014, when he was elected to one of two seats in the 33rd legislative district. During his time in the Assembly, Ramos, a Democrat, sponsored bills involving campaign finance, public employee pensions, student privacy, green roofs, and electronic gambling. Many of his bills won bipartisan support and became law. One of Ramos's main legislative interests while representing Hoboken in Trenton involved improving transportation. He pushed for the Access to the Region's Core line, a proposed new underground train into Manhattan. When Republican governor Chris Christie vetoed the ARC project, Ramos supported the alternative plan to extend the New York Subway No. 7 train into New Jersey, an idea that is still in the proposal stage. Ramos also called for greater financial transparency at the Port Authority of New York & New Jersey, which operates subways, airports, bridges, ports, and other regional transportation infrastructure. Ramos has sharply criticized the port authority's recent rate hikes on commuters and called for a public audit of the agency's books. Ramos's roots run deep in Hoboken. His father worked on the city docks, and his mother, Sonia, has been active in the community. Ramos was the youngest person ever elected to the Hoboken City Council. He won one of three at-large seats in 2001 and served for a time as the council's president. Ramos has honored his Puerto Rican heritage by helping to lead the Puerto Rican Culture Committee, which awards scholarships and raises the island's flag in front of city hall. In 1999, Ramos confronted the biggest challenge of his life. He was diagnosed with Hodgkin's lymphoma. After a tough early battle, Ramos has been in remission since 2000. He sponsored statewide legislation to fund cancer research and support cancer patients. Every year, Ramos remembers his battle by attending the Hoboken Relay for Life walk. Ramos, who lives with his wife, Norma, and their three children, teaches math in nearby Paterson. (Courtesy of Ruben Ramos; photograph by Joe Epstein.)

The Councilman

Ravi Bhalla was first elected to the Hoboken City Council in 2009, representing one of the council's three at-large seats, and for a time, he served as council president. A New Jersey native and son of Indian parents, Bhalla is perhaps the highest-ranking elected official in the United States who follows the Sikh faith. Bhalla works by day as an attorney, and he gained national attention in 2002 for his legal advocacy after a jail visit to a client resulted in a violation of his own civil rights. The incident motivated Bhalla to lead a campaign that pushed the federal government to improve its visitation policies at correctional facilities nationwide. Bhalla has also worked on a pending case involving the New York Police Department's controversial spying on Muslim students in area colleges, including in New Jersey. (Courtesy of Ravi Bhalla; photograph by Quincy Ledbetter.)

The Councilwoman

Though she grew up in Richmond, Virginia, Beth Mason has made Hoboken her home for almost 30 years. During that time, she has engaged the community, notably as a cofounder of the local campaign finance reform group People for Open Government, and by representing the city's northeast second ward in the city council. She has won the Hoboken Rotary's Community Service Award and the Hoboken Quality of Life Coalition's Activist Award. Mason, who is a skilled artist, has supported Hoboken's artistic community. Through her Mason Family Civic League she has sponsored a number of programs, including the art gallery Gallery 1200 and the Mile Square Theatre Company. A former advertising and public relations executive, she lives with her husband, Richard, and their two daughters. (Courtesy of Beth Mason.)

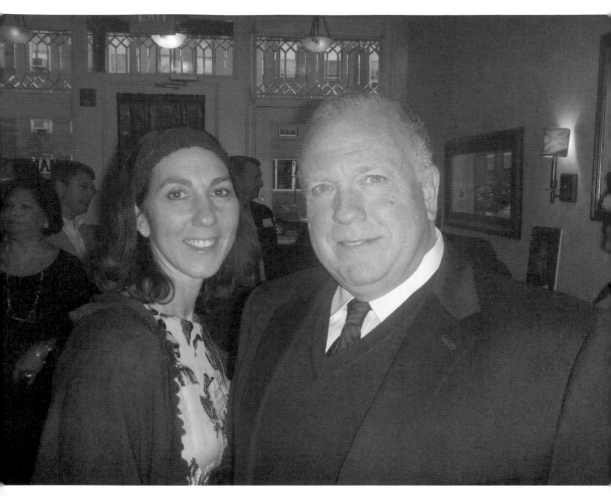

Dave and Anna

David Roberts has done a lot for Hoboken. He served as a firefighter, as a city councilmember, and as mayor from 2001 to 2009. During his time at city hall, the Hoboken native drafted the city's master development plan and comforted survivors on 9/11. But Roberts would likely say that his greatest accomplishment is the life he led with his wife of almost 30 years, Anna, who passed away in October 2013 at age 49. She had been fighting brain cancer for several years prior. Though she had to struggle with the physical rigors of surgery and chemotherapy, and no doubt much mental and emotional stress, Anna Roberts was still able to be a devoted wife and mother to a daughter and two sons. She often said that she was more concerned for her family than she would ever want them to worry about her. She was also a beloved member of the community who served for several years as a trustee of the library and supported many causes from raising money for cancer research to sponsoring a nonprofit bookstore. Hundreds of mourners attended a memorial service for her at SS Peter & Paul Church, the parish she and her family faithfully attended. "Anna was like the Princess Diana of the Mile Square," family friend Carmelo Garcia said. "She was so charitable and brought light into people's lives. She spread her optimism everywhere and was such a huge part of Hoboken—that's truly why this is such a huge loss." (Author's collection.)

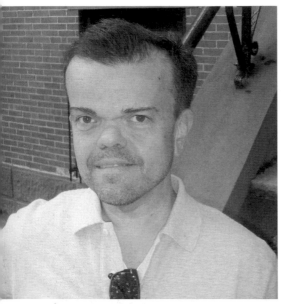

Tough Tony
Hoboken's wild political scene has rattled many, but not Tony Soares, a 20-year resident who serves unofficially as a veteran statesman and strategist for the city's newer, reform-minded political leaders. Soares served as president of the Hoboken City Council and currently serves as a commissioner on the public infrastructure North Hudson Sewage Authority. When he's not debating parks and parking issues, Soares designs homes for Hoboken-based D&G Interior Design and finds homes for clients as an agent with Boutique Realty. (Author's collection.)

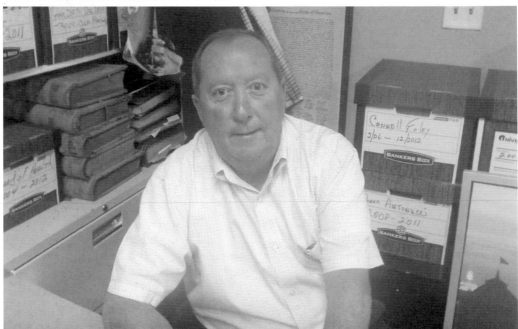

Calling the Roll
The politicians in city hall come and go, but there's always Jimmy Farina. Farina has served as city clerk for over 30 years, calling the roll for nearly every city council vote during that time. His office has also handled organizing Hoboken's elections and other municipal administration. Farina got his start in local politics as a teenager working for future mayor Steve Cappiello, and he served as an elected member of the school board for 36 years. Farina has one of the most extensive collections of Sinatra memorabilia in the city, and he hosts a party every December 12 for Sinatra's birthday. Farina was the coach of the Young Dems Little League team when he recruited Maria Pepe to play, and he supported Pepe during her case to enable girls nationwide to join baseball teams. (Author's collection.)

Mile Square MVP

From time to time Hobokenites will tell their neighbors about how they caught a glimpse of star New York Giants quarterback Eli Manning on the street or in a restaurant. Manning lives in a large apartment in Hoboken's luxury Hudson Tea building with his wife, Abby, and their two daughters. He had already endeared himself to many Hobokenites for leading their favorite Giants to two Super Bowl titles, and Manning has further supported Hoboken by donating to local charities, supporting a citizens group against overdevelopment on the waterfront, and by visiting residents with flooded homes after Hurricane Sandy. (Courtesy of the New York Giants; photograph by Evan Pinkus Photography.)

The Reformer

Bob Bowdon left a notable gig as a reporter for Bloomberg Television to make *The Cartel*, a 2009 documentary about failing public schools that has become a favorite among education reformers, including New Jersey governor Chris Christie. Bowdon continued his interest in education by launching Choice Media, a Hoboken-based outlet that publishes articles and produces video interviews with education experts nationwide. Bowdon contributes to the Hoboken political scene by frequently serving as a moderator for official campaign debates. (Courtesy of Bob Bowdon.)

The Reporter of Record

Diana Henriques has worked as a financial reporter for the *New York Times* since 1989. Besides three other books, she wrote *Wizard of Lies*, the definitive biography of notorious Ponzi schemer Bernie Madoff. Henriques was the first journalist to interview Madoff in prison, and she has appeared on numerous television shows to share insight into his character. HBO is currently adapting the book into a feature film. Henriques also contributed an extended profile of Cantor Fitzgerald, the Wall Street firm that lost over 75 percent of its employees on 9/11, to the *New York Times*'s Pulitzer-winning coverage of the terrorist attack. In 2011, she led a panel discussion in Hoboken on how the city responded to the attack, including mourning the loss of 57 residents. Henriques lives in Hoboken with her husband, Larry, and together they contribute to several local causes. (Courtesy of the *New York Times*; photograph by Fred Conrad.)

The Auteur

Famous actors appreciate getting millions of dollars to star in blockbusters; they act in John Sayles's movies because they're actors. Screenwriter and film director Sayles conceives of many of his probing and provoking story ideas from an uptown Hoboken brownstone office he has shared with his producer wife, Maggie Renzi, since the early 1980s. A Schenectady, New York, native and graduate of Williams College, Sayles started by writing scripts for legendary producer Roger Corman, including the 1970s cult classic *Piranha*. Sayles has worked as a writer and script doctor, sometimes for credit and sometimes as a ghost, for several blockbusters such as *Apollo 13* and *The Quick and the Dead*. He then takes the money he earns to make his own movies. Sayles has written and directed *Eight Men Out*, about the 1919 Chicago White Sox gambling scandal that rocked baseball; *The Secret of Roan Inish*, adapted from an Irish folk story; *Matewan*, about striking coal miners in 1920s West Virginia; *Lone Star*, a murder mystery set in a small Texas town; *Amigo*, about the American occupation of the Philippines during the turn of the 20th century; and most recently *Go For Sisters*, showing two contemporary women from Los Angeles who grew up together but ended up following opposite sides of the law. *Lone Star* earned Sayles the Academy, BAFTA, and Golden Globe nominations for Best Screenplay. Sayles has directed Chris Cooper, Matthew McConaughey, Angela Bassett, Danny Glover, Edie Falco, James Earl Jones, and other famous actors. Sayles, who is an award-winning novelist and short-story writer, also directed the music videos for the Bruce Springsteen hits "Born in the USA," "I'm on Fire," and "Glory Days." (Courtesy of John Sayles; photograph by Mary Cybulski.)

I Got It

Leave it to a cerebral indie rock band from Hoboken to get its name from a comical but obscure baseball anecdote. Husband and wife Ira Kaplan and Georgia Hubley, right, picked the name Yo La Tengo after hearing about an outfielder with the New York Mets who learned the Spanish words for "I got it" to avoid colliding with a Hispanic teammate while chasing fly balls, only to crash into another teammate who didn't speak Spanish. The band Yo La Tengo has had more success. Kaplan and Hubley, with longtime bassist James McNew on the left, have been indie rock legends since the mid-1980s. Despite their national and overseas touring, the band had annually played an eight-night set during Hanukkah at Maxwell's in Hoboken before the club closed in 2013. (Courtesy of Yo La Tengo; photograph by Carlie Armstrong.)

Nothing But Net

Tyshawn Taylor gets to play professional basketball just minutes from where he grew up in Hoboken. The Brooklyn Nets point guard went to St. Anthony High School in Jersey City, where he played for legendary coach Bob Hurley. In 2008, USA Today ranked the school number one in the nation. Taylor then played four years at the University of Kansas. He won the Big 12 Freshman of the Year award in 2009 and played in the national championship game in 2012. He was drafted soon after and traded to the Nets, who are counting on Taylor to contribute to a championship team. (Courtesy of NBA Photos and the Brooklyn Nets.)

The Satirist

Woe to those politicians and business bigwigs who misbehave before multimedia satirist Jeff Kreisler. Kreisler wrote a book called *Get Rich Cheating* in the guise of a sleazy seminar leader who encourages his audience to cheat for success, and he has given an accompanying live performance throughout the United States and within Hoboken through the Mile Square Theatre. He often repackages the book's content on the lecture circuit, where he speaks seriously to businesses and business students about combating greed, promoting ethics, and calling for effective government oversight. Kreisler regularly appears as a pundit on MSNBC and other television channels; ghost writes speeches for national politicians; and has won the Bill Hicks Spirit Award for Thought Provoking Comedy. (Courtesy of Jeff Kreisler.)

Local Laughs

Standup comedian Dan Frigolette had been making a nightly trip from his Hoboken home to perform in famous Manhattan clubs like Caroline's when he realized that many of his Hoboken neighbors were making the same trip to see shows. Frigolette then decided to give Hobokenites great comedy at home. He launched the first ever Hoboken Comedy Festival in 2010 and has been running it ever since. Under Frigolette's management, some top comics have come to Hoboken, including Todd Barry, Amy Schumer, and Judah Friedlander, who have performed at Maxwell's, the Kolo Klub, and other venues throughout the city. (Courtesy of Dan Frigolette.)

Play Nice

Morning television viewers should recognize comedian Chuck Nice, who often appears on *The Today Show* to riff on current events and pop culture. In addition to *The Today Show*, he regularly appears on MSNBC's *Morning Joe*, Vh-1's *Best Week Ever*, WE TV's *Cinematherapy*, Tru TV's *World's Dumbest Criminals*, and other shows. He has hosted *Proof*, a one-hour special on the Discovery Channel. Nice still tours comedy clubs nationwide doing his standup act and has appeared in several television commercials. He got his start in radio in Philadelphia but now lives in Hoboken and served as a headliner during the first-ever Hoboken Comedy Festival in 2010. (Courtesy of Chuck Nice.)

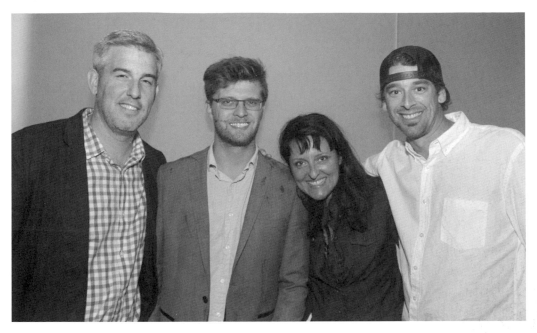

hMAG

By day, Joe Mindak, Simon Dabkowski, and Kevin Cale, left to right, run Tisha Creative, a branding and creative company. But many people know them more for *hMAG*, the slick-sheeted bimonthly magazine the trio publishes about Hoboken's lifestyle, history, and interesting residents with the help of editor Diana Schwaeble. The publishers put the magazine's advertising profits right back into Hoboken. Every month, they host a mixer to benefit a local charity, and they sponsor many other fundraising events throughout the year. The group's biggest accomplishment has been starting the Lackawanna Music Festival, the first independent music festival that draws thousands of visitors to Hoboken's Pier A Park. (Courtesy of *hMAG*; photograph by Cezare Ramone.)

Be Inspired

Always upbeat, Elizabeth Barry has devoted herself to inspiring people, whether they're trying to find some creative spark or embrace a new idea. She runs a branding company, Elizabeth Barry & Associates, which specializes in promoting clients in dance and other fine arts. Barry's business success led her to winning the Hoboken Chamber of Commerce's first-ever Woman in Business award in 2012. The following year, Barry brought several sharp minds together as curator of TEDxHoboken, a local version of the nationally praised speaker series, with plans to make the talks an annual event. (Courtesy of Elizabeth Barry.)

Reformerus Giganticus

There are two halves to Kurt Gardiner. One side involves his serious work as a political reformer. He writes a blog on local politics and ran for county freeholder in 2011, challenging an incumbent who had much more financial and party support. But then there is Gardiner's lighter side. He owns and edits *The Boken*, a popular web site for Hoboken business news and events. Gardiner's specialty is posting scenic Photos of the Day, which he plans to organize into an art exhibit. Gardiner is a recognizable sight at six feet, eight inches tall. He is a regular at the Elysian Bar and Grill and Hudson Tavern, where he sometimes plays the role of DJ Kurt and cuts loose dancing. (Courtesy of Kurt Gardiner.)

A Hoboken Horse of Course

There are sites about Hoboken news and then there's Roman Brice's *Mile Square View*, which has gotten over three million page views since launching in 2009. Brice has attracted readers from inside and outside the city for his posts on Hoboken's wild political scene. His main interest involves exposing corruption in a city where state and federal authorities have arrested and convicted several political figures in the past few years. Brice, who writes under a horse-themed pen name of Smarty Jones, frequently attends city council, board of education, and housing authority meetings, and he often reports on them using angles traditional news outlets do not consider. (Courtesy of Roman Brice.)

President Farvardin
Dr. Nariman Farvardin became the seventh and current president of Stevens Institute of Technology in 2011. He came from the University of Maryland, where he taught electrical and computer engineering for almost 30 years and served as a provost and dean. Farvardin holds seven patents involving communications and has cofounded two companies. Since coming to Stevens, Farvardin has led the school in its current 10-year strategic plan, an ambitious proposal to increase student enrollment, construct cutting-edge classrooms and labs, and add new academic programs. (Courtesy of Stevens Institute of Technology.)

The Techie

Hoboken has become a regional information technology and entrepreneurial hub thanks to Aaron Price, who founded the New Jersey Tech Meetup group in 2010. The group, which has over 3,000 members and counting, is the largest technology social group in New Jersey. It meets monthly on the Stevens campus for gatherings that include networking sessions, start-up pitches, and guest speakers. The group also offers classes on starting and maintaining businesses. Price also cofounded Mission 50, a coworking space at the Hoboken Business Center. Price, who serves as entrepreneur-at-large for the investment firm Gotham Ventures, lives in Hoboken with his wife and daughter. In the aftermath of Hurricane Sandy, Price rallied the tech community to create the Heal Hoboken fund, which raised over $32,000 for local relief efforts. (Courtesy of Aaron Price; photograph by Danny Chong.)

Portrait of the Artist
It seems every child in Hoboken has posed for photographer Mac Hartshorn. Hartshorn, who spent two decades as a fashion photographer, opened a portrait studio in the Monroe Center for the Arts in 2002 that he runs with his wife, Jennifer. The Hartshorns are popular with many of Hoboken's young parents who prefer living in a city to the suburbs and who want to capture images of their young children growing up in Hoboken. The Hartshorns have taken many portraits at Hoboken's scenic waterfront parks. (Courtesy of Hartshorn Portraiture.)

Let's Work it Out
Many Hoboken residents like to stay fit, and many women of all ages do so by taking classes at Work It Out, a boutique gym at 603 Willow Avenue and 5 Marine View Plaza. Owner Noel Descalzi trained for 16 years as a gymnast before having to retire due to an injury. She founded Work It Out in 2010, and since then, she and her team of trainers and instructors have held popular classes for gymnastics, barre, Zumba, spinning, Pilates, and more. Many of Work It Out's members are young mothers who get to exercise with their kids in tow. (Courtesy of Work It Out.)

Metro Moms

Kathy Zucker found many other young mothers in Hoboken who shared her dilemma. She was raising a family but still wanted to maintain a career. Zucker, on the left, formed a networking group to help women work part-time as consultants in their respective fields. The group grew quickly into the Metro Moms Network, which in addition to consulting also publishes articles on parenting and hosts a biannual expo for parents to meet experts, service providers, and product vendors. Zucker, a career corporate marketer, is a social media whiz who won a 2013 Shorty Award in the Keep Going Good category for inspiring parents to be passionate about their families. (Courtesy of Kathy Zucker.)

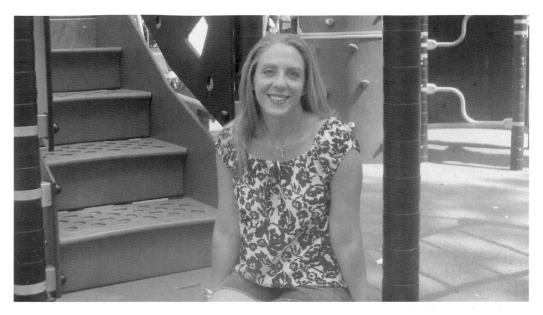

Project Play
Zabrina Stoffel had thought of herself as just a mom who liked taking her kids to the park. When she noticed the playground at Church Square Park needed serious repair, Stoffel went into action. In conjunction with the Hoboken Family Alliance, she organized a group, Project Play, to raise money to renovate the swings, slides, and other playground equipment. The group partnered with local businesses and got donations from residents. It collected and gave over $50,000 to the City of Hoboken, which used the money to start a major renovation of the entire park. After her success with the park, Stoffel has used her fundraising skills to help the Mile Square Theatre Company, the HoLa Dual Language Charter School, and the Hoboken Boys & Girls Club. (Author's collection.)

An Authentic Man
Every woman in Hoboken with a sense of style shops at Midtown Authentic, the luxury consignment store on Seventh and Garden Streets. Owner Rory Chadwick is an expert on Chanel, Louboutin, and other couture. Chadwick is also one of Hoboken's great samaritans. As an individual and through his membership in the Hoboken Rotary, Chadwick has donated and raised money for numerous causes, especially the Hoboken Shelter. He took the lead in organizing large benefit parties after Hurricane Sandy and the fire that destroyed 300 Washington Street. (Author's collection.)

Mr. Mangia

Avi Ohring is a familiar sight to many Hobokenites, who often see him riding his bicycle on the city's streets while wearing a baseball cap backwards. Though he was not born in Hoboken, Ohring often visited as a child with his father, who was a professor at Stevens. Ohring now runs the popular Mangia Hoboken, a food tour that takes visitors across Hoboken's culinary landscape, including to Carlo's City Hall Bake Shop, the Antique Bakery, Fiore's Deli, Lisa's Deli, Grimaldi's, Empire Coffee & Tea, Sweet, and other stops. Ohring also volunteers for the Hoboken Historical Museum, serving as a tour guide for the museum's annual home and garden tours. (Author's collection.)

Paul's Design

Interior designer Paul Somerville's roots in Hoboken go back five generations. His paternal great-great-grandfather, Bavarian-born Adelhart Englert, came to Hoboken in 1881. Somerville has served Hoboken as a commissioner and chairman on the Historic Preservation Commission and as president on the board of directors for the Hoboken YMCA. A gifted child artist who studied at the New York School of Interior Design, Somerville has also lent his aesthetic expertise to the city, helping to renovate Hoboken's city hall and the Hoboken Historical Museum. He lives with his husband of 28 years, Hoboken Public Library trustee Allen Kratz. (Courtesy of Paul Somerville; photograph by Ralph DeMatthews.)

The Turtle Club Today
When David Hohensee, left, and Cory Checket, right, needed a name for the bar they wanted to open on Tenth Street and Park Avenue, they chose one that invokes Hoboken's long epicurean history. Their modern version of the Turtle Club is a popular neighborhood bar, dinner-date restaurant, and weekend dance club. Checket and Hohensee have also hosted numerous fundraisers for nonprofits, and they also cohost an annual summer block party with neighboring bar 10th & Willow. (Author's collection.)

See You at the Shannon
Marie Wall and her daughter Tara run the downtown bar the Shannon, which Marie's parents started in 1956 after they came from Ireland. The mother and daughter have made the Shannon one of Hoboken's most versatile bars. Located on Hoboken's "Irish Row" on First Street, the Shannon caters to pool-playing neighborhood regulars, sports fans, and twentysomethings who like dancing to disc jockeyed music in the bar's back room. (Author's collection.)

Little Town in the Mile Square City

Brothers Albie and Chris Manzo, second from the left and second from the right, respectively, are famous to audiences nationwide because their parents are regulars on the Bravo network reality television show *The Real Housewives of New Jersey*. But the brothers, whose family owns the Brownstone event hall in nearby Paterson, are becoming more famous in Hoboken for running Little Town, a New Jersey–themed restaurant on the waterfront built into the ground floor of the brothers' apartment building. The Manzos partnered with Michael Sinensky, left, and Sean McGarr, right, to open the restaurant. Sinensky and McGarr own several bars and restaurants in Manhattan and came to Hoboken in 2010 to open the Village Pourhouse sports bar on First Street. (Courtesy of Little Town.)

Hey Joe

"I didn't find Hoboken, it found me," Joe Branco likes to say about how he came to the Mile Square. He grew up in a Brooklyn housing project but earned his way to New York University, where he got a degree in hotel and restaurant management. He was managing a bar in Manhattan in 1998 when by chance he met the owner of a building in downtown Hoboken who ended up begging Branco to buy the bar downstairs. "I kept saying, no, no, I'm not interested," he recalls. "Finally she said, do you want to run someone else's bar or run your own? Then I said I have to at least take a look." Though he didn't know anything about Hoboken, including its exact location, Branco came for that look. He saw enough potential in the bar to buy it, and he has been running the Room 84 nightclub ever since. He also owns a second bar, Scotland Yard, across from the Hoboken Terminal. Branco lives with his wife, Jen, and their two children, and he remains active in the community that he says welcomed him. He has sponsored youth athletic teams, served with the Rotary and Hoboken Dads groups, and donated Room 84 for community events. (Author's collection.)

Hans's Hundred

A book about Hoboken notables should include a notable who wrote a book about Hoboken. Historian and artist Jim Hans published *100 Hoboken Firsts* in 2005. Hans found that Hoboken and its residents sold the first package of Oreo cookies, created the ice cream cone, built the first touch-tone telephone, and installed the first public air-conditioner, among many other historic feats. (Courtesy of HHM.)

New Blue Eyes

Every year, Hoboken honors its most famous native son, Frank Sinatra, with a city-sanctioned Sinatra Idol singing contest. Dozens of Sinatra tribute singers from all over the United States come to Hoboken every June—specifically to the city's waterfront Sinatra Park—and compete to see who among them best captures the essence of Ol' Blue Eyes. Hoboken native Eric DeLauro won the contest in 2009, and he now performs regularly at parties, cultural events, and festivals throughout Hoboken and the New York City area. (Author's collection.)

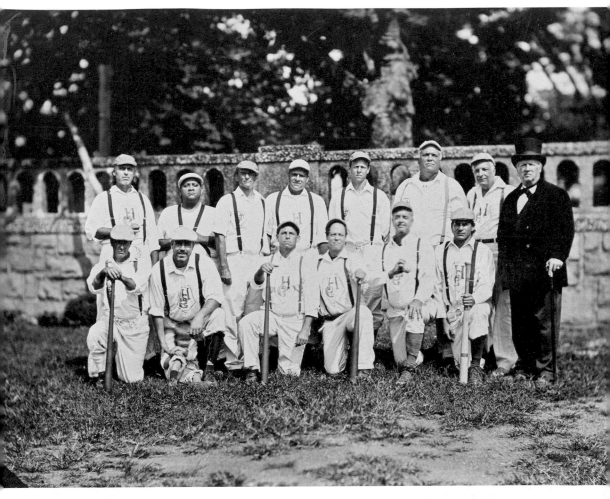

The Home Team

For the past few years, the Hoboken Historical Museum has organized a baseball game every June, following 19th-century rules, to commemorate the 1846 game between the New York Nine and Alexander Cartwright's Knickerbockers. The museum would try to recruit players a few days before to meet the visiting Flemington Neshanock, a team that has played vintage rules games up and down the east coast for years. The games between the Neshanock and the ad hoc Hoboken team would usually end in blowouts. However, the museum saw enough potential in the Hoboken players to begin sponsoring them as a team year-round. The full-time and permanent Hoboken Nine formed in 2012 and have played against other vintage teams throughout the region, including almost 75 games in 2013. Led by captain Frank Stignone, back row, fourth from the left, the team regularly practices and codifies its positioning and lineups. The team has improved quickly, even beating the Neshanock in a few rematches. (Courtesy of HHM.)

This Is Our Waterfront

The Hudson River waterfront is Hoboken's crown jewel. Virtually every resident has enjoyed attending events on the waterfront's piers and parks, or they have eaten a nice meal at one of the waterfront's restaurants, or they use the waterfront for their jogging route. Seemingly the whole city comes every Fourth of July to watch the Macy's fireworks show in the Hudson. But no one in Hoboken would get to enjoy the waterfront today without Helen Manogue, who helped fight for years to keep it in public hands and away from outside corporations. Manogue moved to Hoboken in 1961 when her professor husband got a job at Stevens. She would take their children on walks and survey the town. "The city was in terrible shape then," Manogue remembers. "The waterfront was especially bad, to the point where there were packs of wild dogs roaming about." The old shipping lines had moved to larger ports, leaving the Hoboken waterfront in ruins and without a use. Manogue had supported the environmental movement, and she believed in the ancient Roman doctrine that said the public should have access to bodies of water. During the early 1970s, when oil companies wanted to use the Hoboken waterfront and potentially pollute the environment, Manogue and other activists rallied public interest to stop them. They educated voters, enlisted help from the Sierra Club and other groups, and consulted experts from Stevens to support their case. They succeeded then and in a following series of battles, and years later, Hoboken was able to develop the waterfront for public use. "That's what we envisioned all those years ago," Manogue said. (Author's collection.)

Kiss Me, I'm Irish

Chris Halleron's job as a marketing rep for Budwesier transferred him from his native Syracuse to Hoboken in 1997. To earn extra money, he started bartending at Duffy's, which has since become Cork City on Third and Bloomfield Streets. There Halleron met Ann Wycherley, a bartender who had recently come to America from Dublin. The coworkers became friends, and Halleron eventually suggested they go on a date. She said yes. "He wore me down," Wycherley remembers. They dated off and on and finally on enough to get married in 2008, in a small ceremony at Hoboken's Pier A Park. Their son, Jack, was born later that year. In many ways, Chris and Ann are the quintessential Hoboken couple. Their lives converge with many of the city's touchstones. Chris's ancestors were Irish, and Ann was born in Ireland, a heritage they share with thousands of other Hobokenites in history. They met in a bar, just like countless couples who have met and fallen in love in the city's bountiful nightlife scene. Ann works as a real estate agent for Century 21, in what is arguably Hoboken's strongest industry. Chris has worked as an editor for the *Hudson Reporter* newspaper and *hMAG* magazine and has come to understand Hoboken's veterans, its arts scene, and many other stories about the city's people. Ann made sure to keep Duffy's open on 9/11, because she knew on that day especially people needed to be able to come to a familiar place. Chris, Ann, and their son, Jack, are a young family who, like many others lately, choose to resist what used to be the default move to the suburbs. They want to stay in Hoboken. "I've been thinking of leaving for 10 years, but there's always something that's keeping me here," Chris said. "We don't really know where else we'd go," Wycherley said. "And Jack seems pretty happy here." (Author's collection.)

INDEX

INDEX

AN IMPRINT OF ARCADIA PUBLISHING

Find more books like this at
www.legendarylocals.com

Discover more local and regional history books at
www.arcadiapublishing.com